Drawing the Games

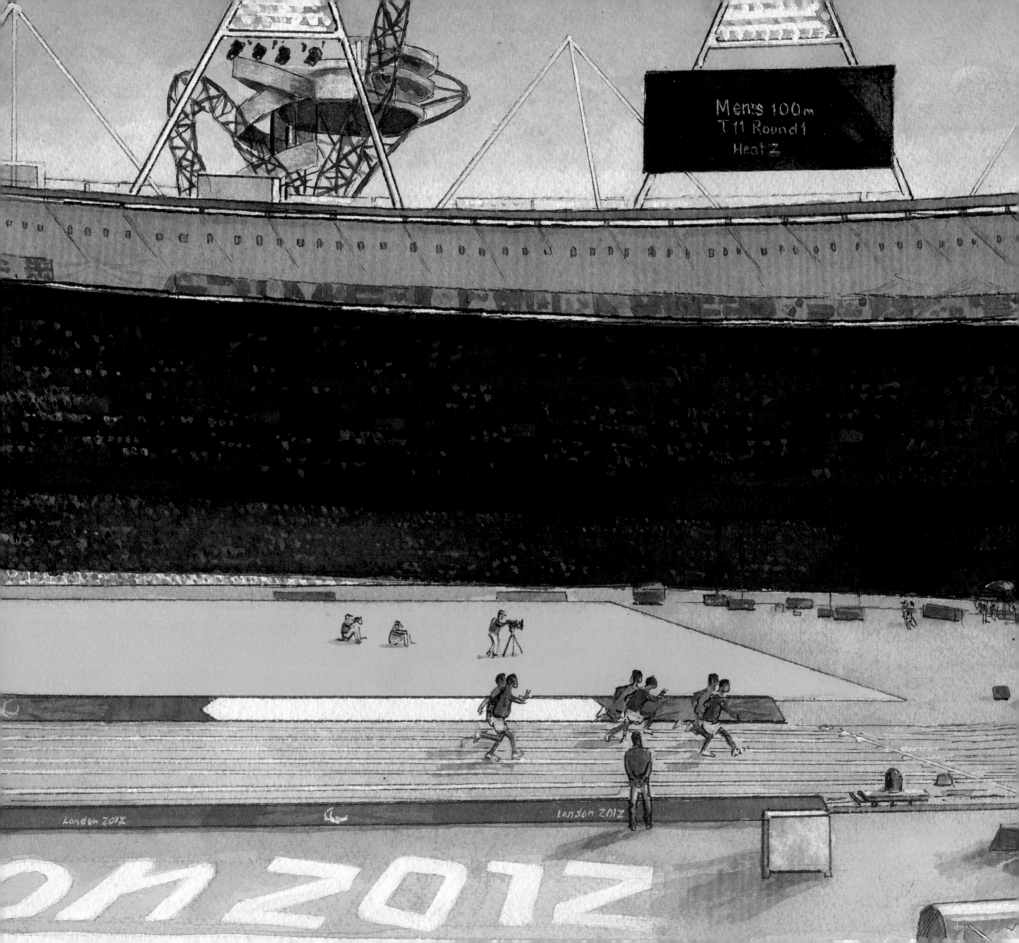

Drawing the Games

A story of London 2012 commissioned by the Mayor of London

Nicholas Garland

Foreword by Boris Johnson • Commentary by Richard Dorment

For Irma ~
love Nick
Sept 2013

MAYOR OF LONDON

Acknowledgments

I would like especially to thank Stephen Robinson, Richard Dorment, Andrew Brown, Pat Hardy and my wife Priscilla for their constant advice and encouragement, and of course to Boris Johnson, whose idea it was. This project would not have been possible without the commitment of everyone at City Hall, especially Munira Mirza, Veronica Wadley, Justine Simons, Kirsten Dunne, Sally Shaw and the Culture Team.
Nicholas Garland

First published in the United Kingdom in 2013
by the Greater London Authority

Copyright © 2013 Greater London Authority
Text copyright © 2013 the authors
All illustrations copyright © 2013 Nicholas Garland

British Library Cataloguing-in-Publication Data
A catalogue record for this book is available
from the British Library

ISBN 978-1-847815-52-1

Greater London Authority
City Hall
The Queen's Walk
More London
London SE1 2AA

Enquiries 020 7983 4100
Minicom 020 7983 4458

london.gov.uk

Edited, designed and produced by
Art Books Publishing Ltd
www.artbookspublishing.co.uk

Production by fandg.co.uk
Reprographics by Dexter Pre-media, London
Printed and bound in Italy by EBS

Contents

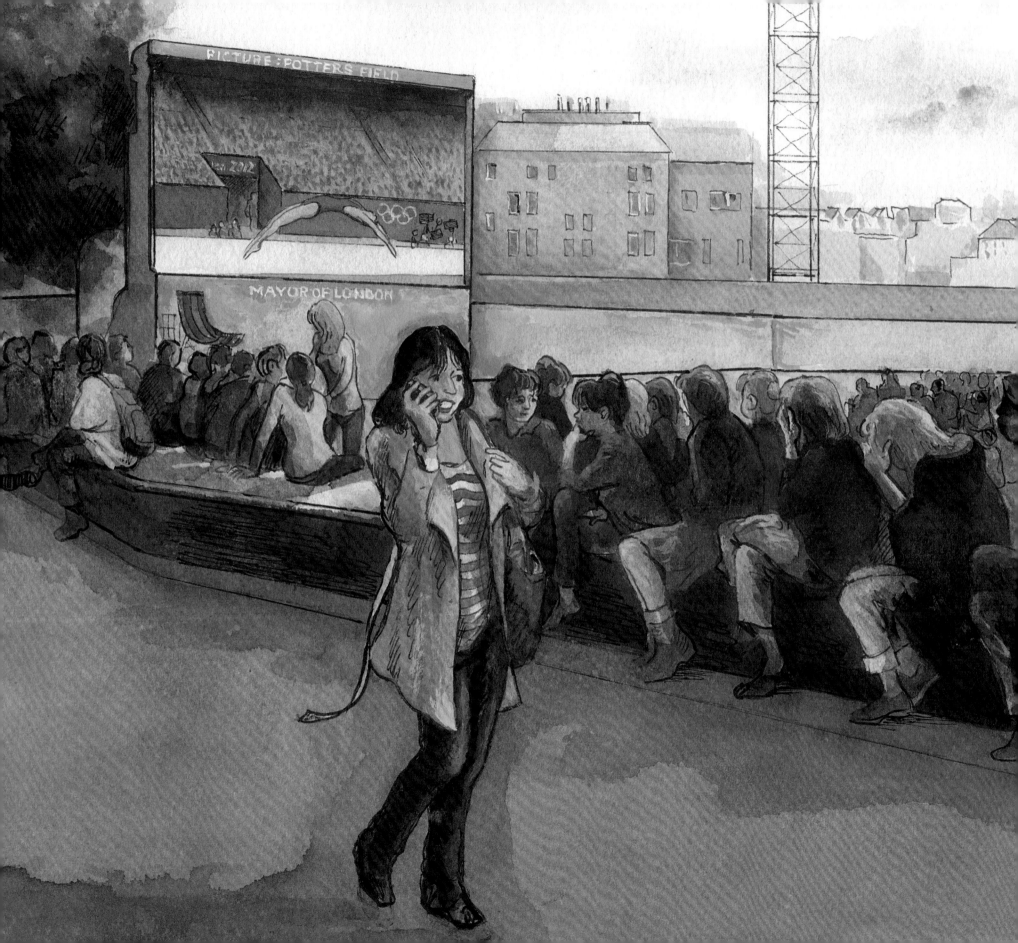

Foreword

Boris Johnson, Mayor of London

A year on from that golden summer of 2012, the whole thing is starting to feel a bit like a dream. It was a time when things failed spectacularly to go wrong, when we all put aside our normal cynicism and surrendered to a kind of magic. The transport system functioned more or less perfectly; the security guards eventually turned up (and had superb support from the armed services and the police); the weather was good to fair throughout – ideal for a garden fête.

The world's athletes performed magnificently against a backdrop of breathtaking venues and beautiful historic buildings. And British athletes did better than ever before, both in the Olympic and Paralympic Games. For many of us it was clear that this was the biggest thing we would ever be involved in – an extraordinary moment when people felt united and excited in the most benign way possible.

Throughout those intoxicating days, Nicholas Garland was in the crowd, watching the sport, and watching the people watching the sport. He wanted to capture the mood, the action, the pathos, the little vignettes – and he wanted to use his painting and drawing to interpret those scenes in a way that no photograph can quite achieve. He was the 'war artist' of the biggest peacetime operation any city can be asked to put on, and he rose spectacularly to the job. Look at his pictures and it all comes flooding back.

The giant 'Live Site' screen in Potters Field Park beside City Hall and Tower Bridge

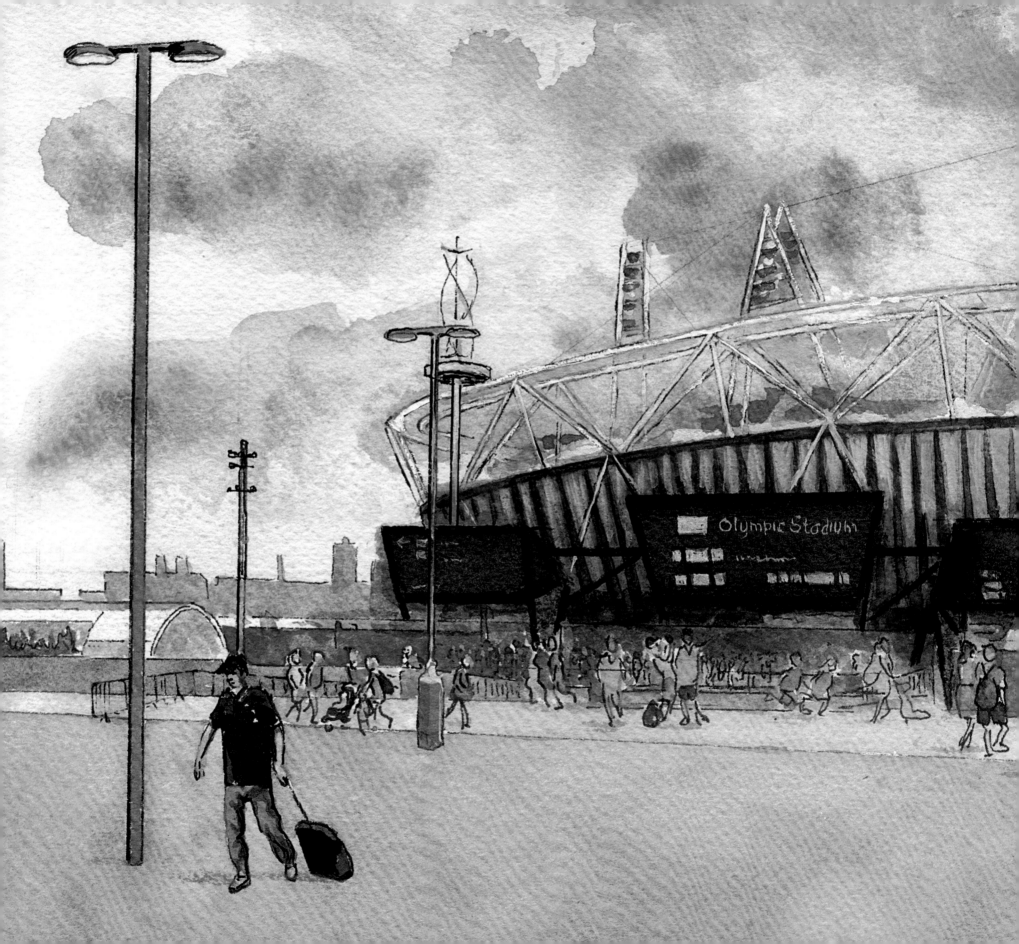

A summer like no other

Richard Dorment

As Nicholas Garland describes in this book, Boris Johnson's inspired, if somewhat vague, suggestion that he go to the Olympic Park and 'draw the Games' was a lot easier said than done. Initially, Garland interpreted the Mayor to mean that he wanted an artist to do drawings of the sporting events. But before the Games began, he figured out that such drawings could not compete with the work of photographers and television reporters. While he could not ignore the athletics, he realised that his main subject was going to be London, the Park and the people. He knew that it is often the recall of small details to one side of the main action that most powerfully brings the past to mind.

Garland is better known as a political cartoonist than as an artist who trained at the Slade School of Fine Art, but he is in fact both. He is able to work in several different mediums using a variety of techniques. To depict athletes in action, he made quick sketches on the spot. But for other subjects in and around the Park he returned to his studio to create a series of carefully worked-up pictures in gouache and ink. And this is where his documentation of London's Olympic summer is unique among all the many images of the event I have seen. Most of Garland's pictures depict nothing very special: families strolling through the Park, a policeman wishing visitors a safe journey home, an elderly couple perhaps up from the country apparently more interested in a flower garden than in the long jump. And in a surprising change both of medium and of mood, he turned to the woodblock print to make a series of close-up portraits of the athletes, thereby engaging in a more intimate way with some of the stars of the Games.

For all the range and diversity of his subject matter and working methods, the record he made of those extraordinary weeks in 2012 feels like a single unified body of work. As is reflected in the order in which the reproductions are arranged in this book, Garland saw the project as a series that should be read as a narrative sequence. We encounter the sights as the public would have seen them, beginning with the journey by Tube to the East End, the approach to the Park, the security clearance, the opening ceremonies, and, finally, the athletes in competition. It is perhaps too early to suggest that our grandchildren will be fascinated by the picture showing people going through something called a 'scanner' at security, the colourful clothes children wore in the early years of the twenty-first century, and their hilarious 'trainers'.

You would be surprised how rare it is in art to see pictures of ordinary people doing nothing in particular. Garland noticed what most of us would have overlooked: the way a young man and his girlfriend smile at each other as they walk through a sudden shower of rain; a family asking one of the endlessly helpful volunteers for assistance; or a mother posing two heavily armed policeman with

her little girl while she takes their photograph. Taken one at a time and out of context, you might miss what is interesting about these everyday scenes. But to see them in sequence is to realise how perfectly Garland captured the ineffable atmosphere of goodwill and high spirits that was such a feature of London's Olympic summer.

But how did he do it? How did he get it all down in a way that looks so effortless, so natural? It does not take a great deal of imagination to realise that only years of practice in drawing from life enabled him to capture in a few calligraphic strokes of his pen the vectors of arms and legs, the torque of bodies or the distribution of weight as athletes propel themselves over hurdles or launch themselves into space. But how did he draw the four separate stages of a high dive – something the human eye cannot actually see, except as a blur? The answer should be obvious to anyone who watches sport on television: Garland saw the dive as it happened in real time, but made sense of what he had just seen by watching it again as it was replayed on the big screen, often more than once and sometimes in slow motion. Without the aid of modern technology, he could

not have seen what he shows so clearly in the sketches: how the diver crosses his arms over his chest as he somersaults and flips through the air.

But photography or film plays a relatively small part in Garland's creative process. Much more important both in the quick sketches and in the finished works in gouache is his use of a technique employed by the old masters – including on occasion J. M. W. Turner and James McNeill Whistler – when they wanted to treat a subject that for practical reasons they could not draw from nature: he relied on his highly trained visual memory. Having made a quick pencil drawing of the figures he wanted to include in each picture, he spent a long time just looking, committing to memory what he had just seen. He took some photographs of the buildings and crowds surrounding each motif, but he did so only to ensure the accuracy the background in each scene. Back in his studio, he set to work transferring his memories and notes onto paper, sometimes while the images were still fresh in his mind, but just as often weeks or even months later.

And this is what I admire most about his achievement. For all his manual skill, much of what I have described so far could still be categorised as journalism – a kind of sophisticated visual reportage. Nothing wrong with that. But where the series really takes off is when Garland the artist takes over, spotting the moments of unexpected beauty or human pathos. It happens when he is drawing a father descending a steep flight of stairs with his sleepy little daughter draped securely over his shoulders; or when he stops to record the beauty of a mass of umbrellas moving slowly towards the exit in a downpour; or in his study of a crowd strolling in the Park when what really interested him was the pattern of shadows created by sunlight falling through the leaves of a newly planted tree.

Had Garland only drawn and painted the men and women who performed in the Olympic and Paralympic Games, the art work he made last summer would still have been one of our most valuable records of an amazing event. But he went further and achieved much more by focusing on the visitors from all over the world who came to cheer the athletes and enjoy an event that felt like an old-fashioned world's fair. The result is an evocation of that summer like no other we have.

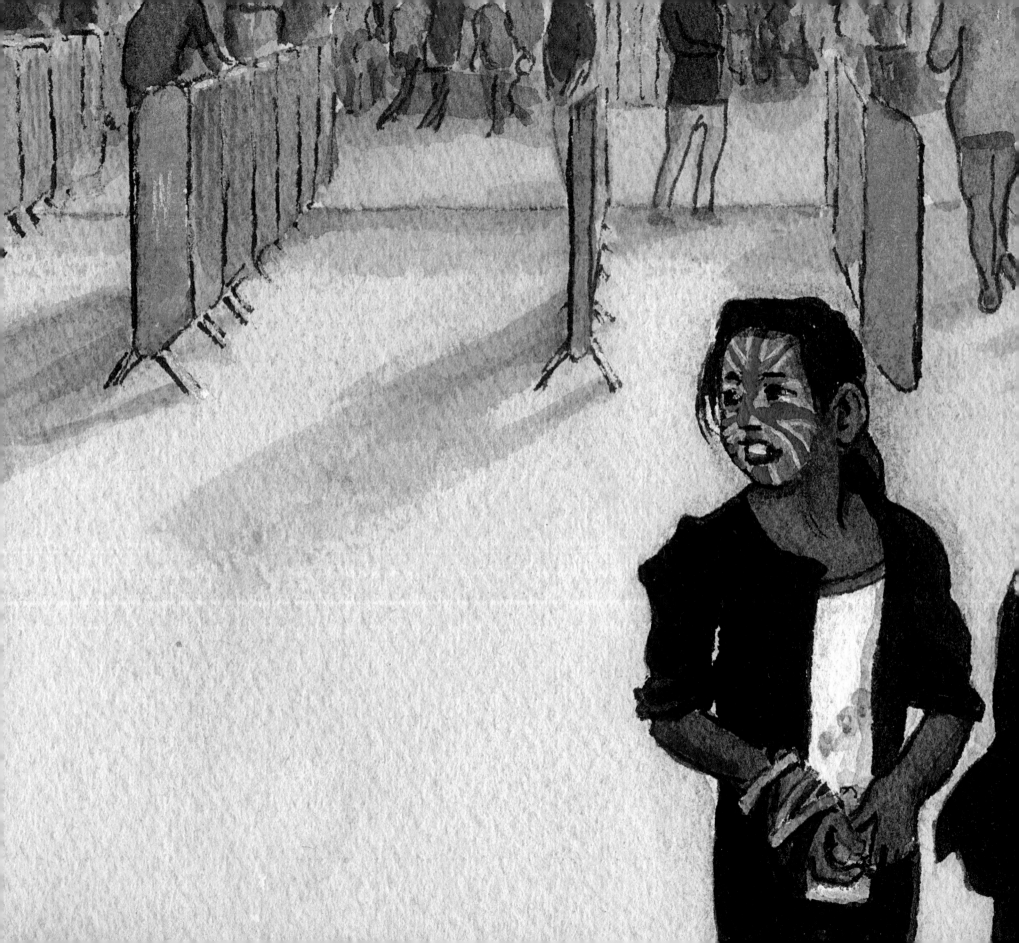

'Go to the Games and draw them'

Nicholas Garland

On 21 June 2012, I began to write a journal. The first entry reads: 'I am waiting for a phone call from Boris Johnson's office. He rang a week ago to confirm that he wanted me to be an official artist of the Olympics.... This plan had come to him over a year ago. He'd said "I've just had a great idea!" then, as if addressing himself, he said "No – Yes! I'm going to do it!... You should be the Artist of the Olympics. You know, go to the Games and draw them. It'd be brilliant." Half laughing, but obviously serious, he asked me what I thought – was I interested? I said, "Yes of course I'm interested."' This is where the journal ends. The phone call came, and after that I was too busy to keep a diary.

I realised immediately that I had agreed to undertake a task without having any idea what the task was. I wrote to a friend a couple of days after the Olympic Games had started. 'It is hard to know what to focus on, because the Games are a coming together of so many completely different things: a gigantic security operation, a traffic congestion nightmare, an enormous commercial opportunity, a carnival, an athletics events, and sometimes just a great bore. I don't yet know how to draw the Olympics. I don't know what style or degree of accurate representation I should be aiming for. To work that out, I have to decide what the drawings are going to be of. I am coming to believe that my subject is London and its patient, tolerant, good-humoured, independent people. I think I will leave the athletes to the photographers and stick to the streets and the Park.'

It had been some time since I had done any journalistic drawing from life. I used to do it

years ago for the *Daily Telegraph*, but I had lost the knack. So before the Games began, I practised drawing in the streets near my home and in Regent's Park. But first I rang Posy Simmonds, who is very experienced and exceptionally talented at this kind of sketching, to ask for advice. She gave me three useful tips: carry your materials in a bag that won't fall over and empty everything out each time you put it down; take with you a box of coloured pencils; and as you work, note any remarks you chance to hear people make.

As I practised, I began to remember how I used to do it. If you start to draw a woman with a pushchair, say, walking towards you, she will have passed you and be disappearing into the distance before you have jotted down the outline of her head and shoulders. The trick is not to draw but to look – to scan her as she approaches. Once she has gone, you draw the snapshot in your mind's eye before it fades. Later, in the Olympic Park and elsewhere around London, I did scores of drawings in this way, sometimes also taking photographs of backgrounds or settings in order to have those references to hand when I came to do the finished art work back in my studio.

For that kind of larger, worked-up composition, I tried at first to develop a swiftly executed style of bold charcoal drawing with bright gouache colour. There was so much ground to cover, I felt I hadn't got much time to spend on any particular picture. I reminded myself of Eugène Delacroix's remark, 'If you are not skilful enough to sketch a man jumping out of a window in the time it takes him to fall from the fourth storey to the ground, you will never be able to produce great works.' I am also all too familiar with the experience of drawing a picture to death. I sympathised with a distinguished cartoonist friend of mine who told me once that, in despair over what he thought were his own laboured overworked drawings, he tried to lighten them up by working left-handed in a moving train.

But while working fast can add vigour and movement to your art, it is useless for the accumulation of detail that was essential for the job I was doing. I began to take longer and longer over each picture, while bearing in mind another of Delacroix's observations: 'Experience has two things to teach us. The first is that we must correct

a great deal, and the second – that we must not correct too much.'

In the end I established two distinct styles. One was for drawings that were carefully and slowly worked up from sketches, memories and photographs; and the other was for swiftly executed drawings from life of competing athletes. I also produced some woodcuts. I used this medium to create portraits of some of the great athletes because of the particular quality of black-and-white simplicity that is characteristic of this kind of printing.

The Games gave me several unforgettable moments. Watching Mo Farah winning the five thousand metres was one of the most beautiful things I'll ever see. Many of the athletes moved me deeply, and not just by throwing something further than I would have thought possible, or by jumping higher or by balancing on less. Simply to watch them limber up before an event or walk towards the starting blocks was to see a sort of perfection in motion.

But there were other pleasures that were even more touching and quite unexpected. For instance, the moment when the entire Stadium noticed, as a distance race ended, that one runner – almost lapped by the rest of the field – still had a lone circuit to run. She didn't give up or slow down and, as she ran on, the crowd began to applaud her and then to roar their approval until, as she came down the last hundred metres, it was as if she were winning the gold. I don't think either the athlete or anyone in the crowd took this moment wholly seriously. It was boisterous and spontaneous and warm-hearted, and it got as near to what was best about the Olympic Games as anything else I saw … except for something I noticed during the Paralympics two weeks later.

The Stadium, the Park and all the venues were as full during the second set of games as they had been a fortnight before. The Paralympians had trained just as hard and competed just as fiercely as the Olympians had. The cheers and the applause were just as wild. The difference was that during the Paralympics, along with the admiration and excitement the events provoked, there was something else in the air that I do not know how to describe. It was a bit like respect but more like awe.

Then there were the volunteers. Have crowds ever been controlled by such affectionate authority? Where did they find people prepared to give up so much time, who never got tired, who were always helpful, who greeted you in the morning and hoped you'd had a good day when they called out 'Safe journey home' as you left late at night?

In all the many times I was part of the crowd, sitting in trains, queuing for food, walking to the next event, or waiting, drawing and watching, I never saw anyone pushing or hurrying past. I heard no sharp exchanges, saw no confrontations. There were old people and tiny babies, spirited boys and girls, parents, groups and singles of many races from many nations – all were even-tempered, excited but amiable – strangers but united.

I hated the build-up to the Games. I thought they had been inflated into something repugnant – a horrible mix of nationalism and greed. Towards the end, I was in the Park one afternoon. It was hot and crowded as usual. I was tired but still due to attend that evening's events. To my surprise, I began to feel quite sad. I texted my wife, 'I'm going to miss this.'

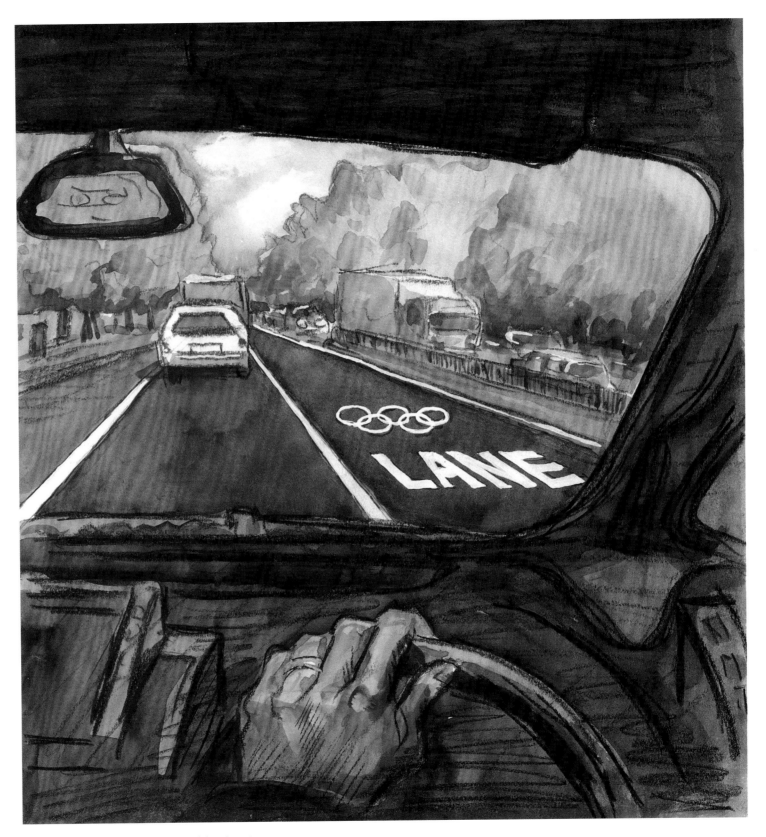

Heading to the Games alongside one of the Olympic Lanes

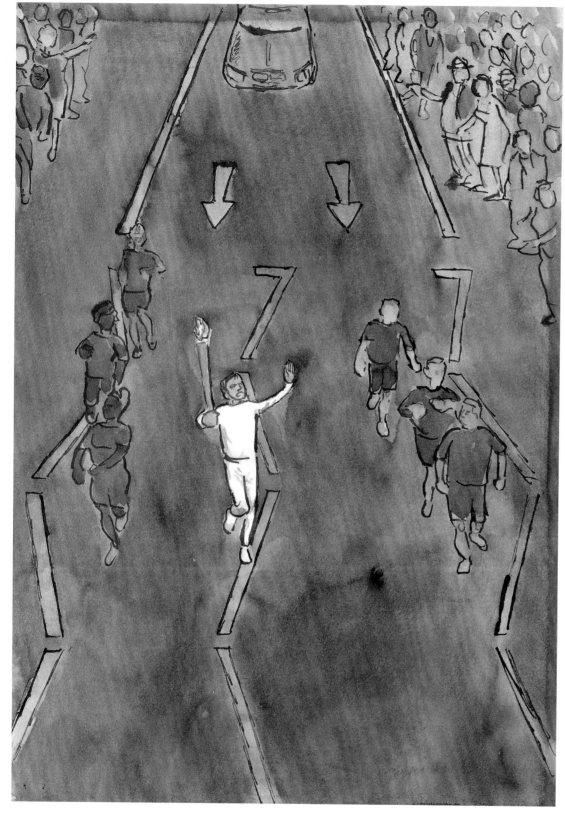

The Olympic Torch makes its way to the Park in the build-up to the Games

'Most of what I saw as the runners carrying the Olympic Torch drew near was waving iPhones.'

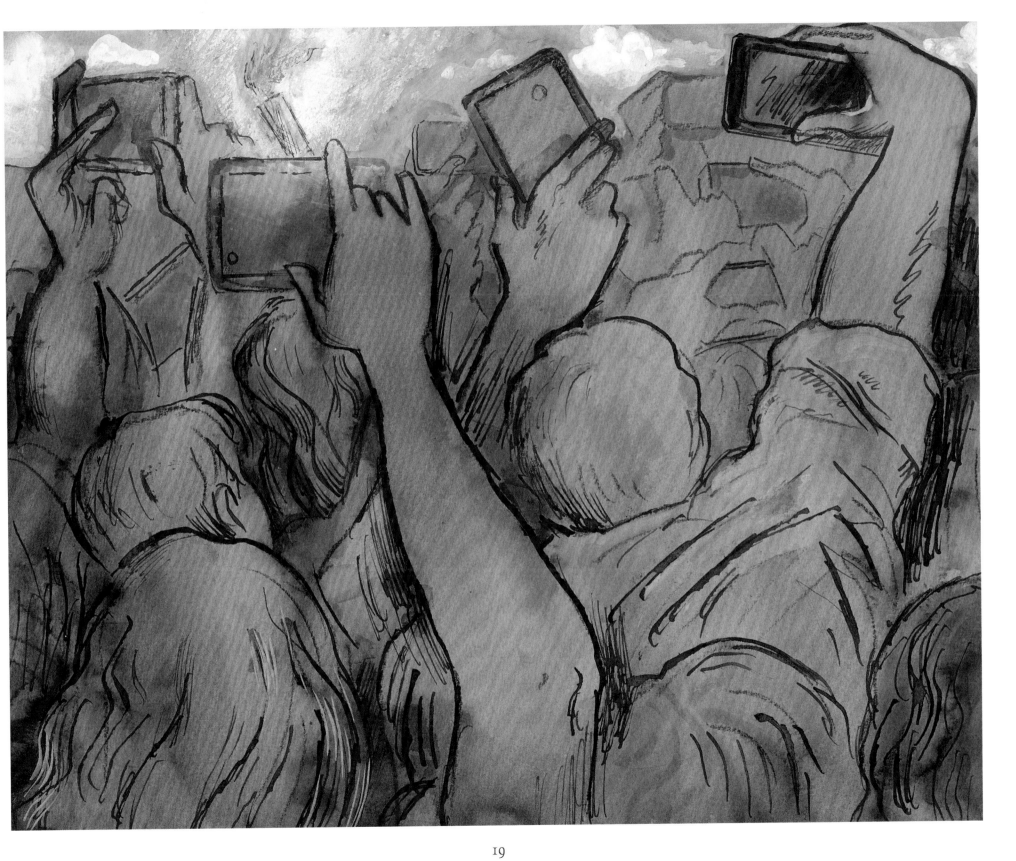

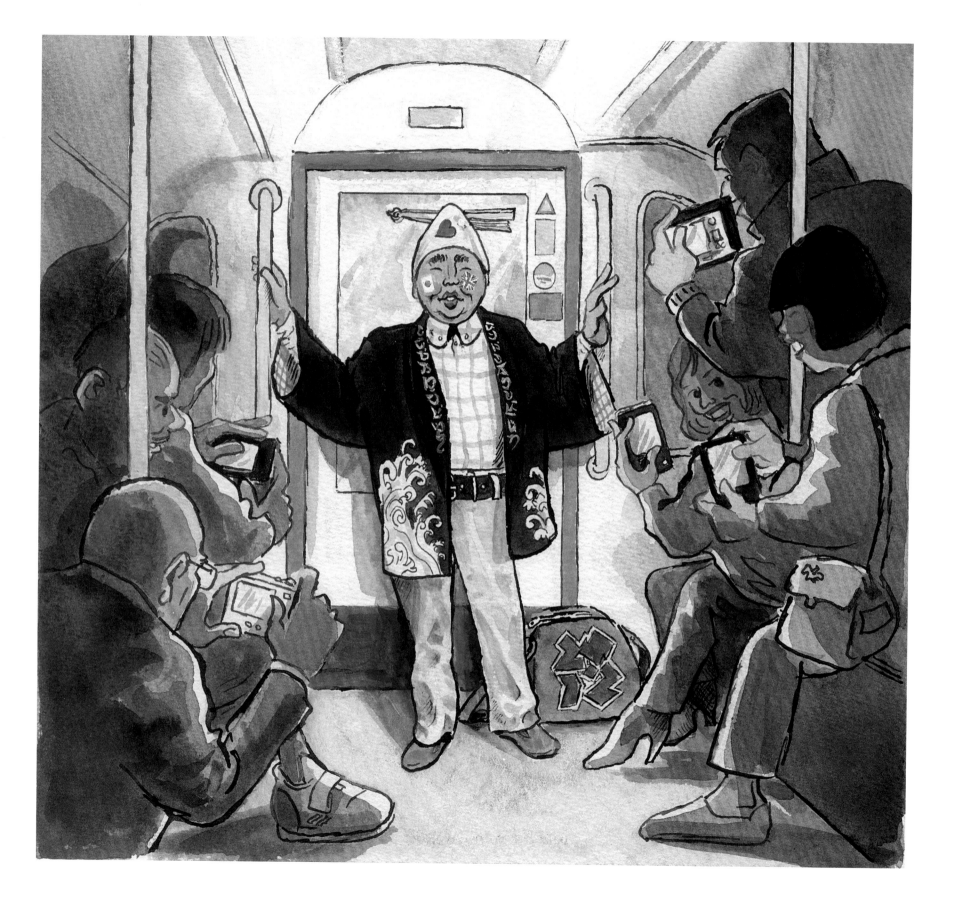

'A carnival mood gripped London as the Olympic Games got underway. On the busy Underground, the sound of people talking and joking was as loud as the familiar rattle of the train. A typical scene was this Japanese gentleman posing to amuse his fellow passengers, who crowded round him calling out and laughing and photographing his colourful outfit and brightly painted face.'

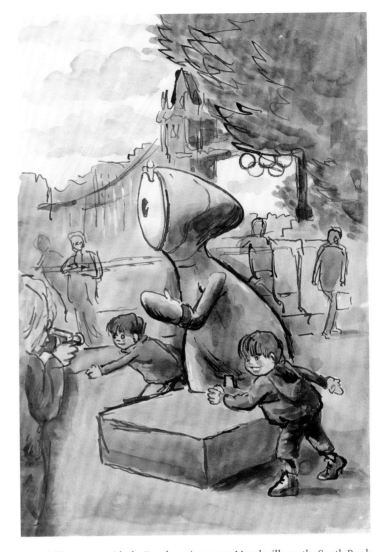

Two children pose with the Paralympic mascot Mandeville on the South Bank

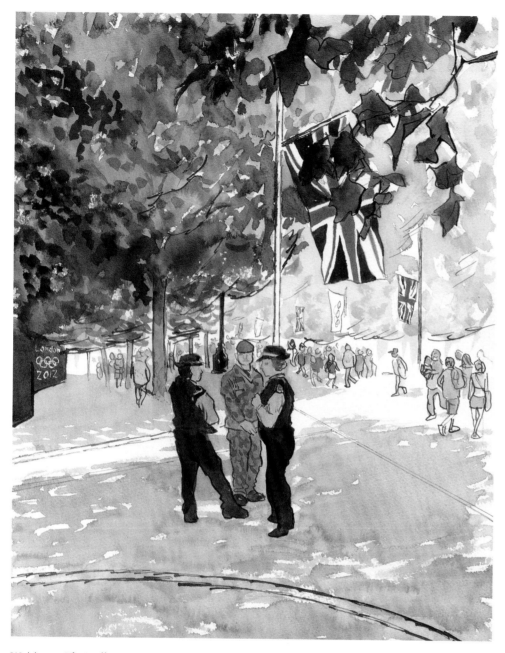

Waiting on The Mall

'In the Park, younger volunteers began greeting people, particularly children, with high fives. Very soon the practice spread and became almost de rigueur. This volunteer was calling out to everyone who passed "High fives! High fives anyone?!"'

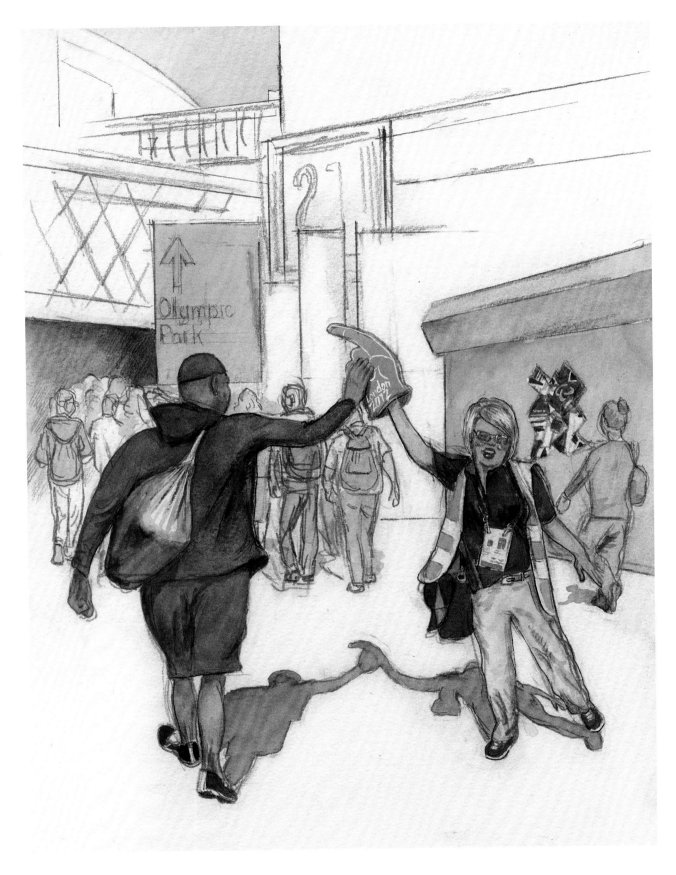

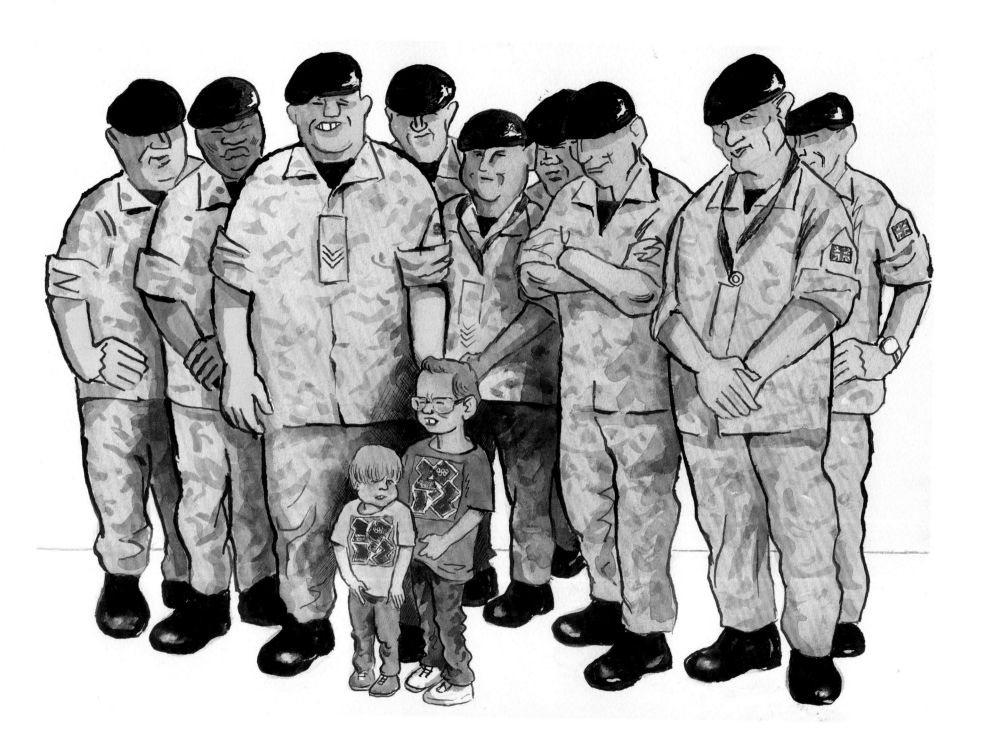

'These two little boys appeared
to be beside themselves with
embarrassment while their parents
laughed and took photographs
and the soldiers grinned and joked
among themselves.'

'The soldiers on security detail
were always extremely friendly as
well as businesslike. These young
men and women in uniform played
an important part in creating the
confident, lighthearted mood that
was in the air all through the Games
in London 2012.'

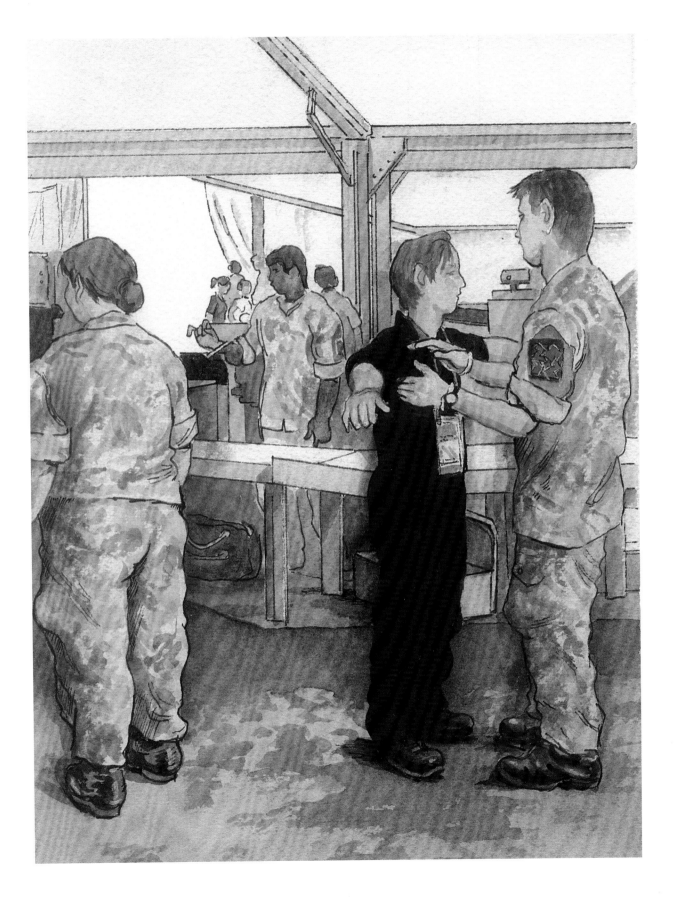

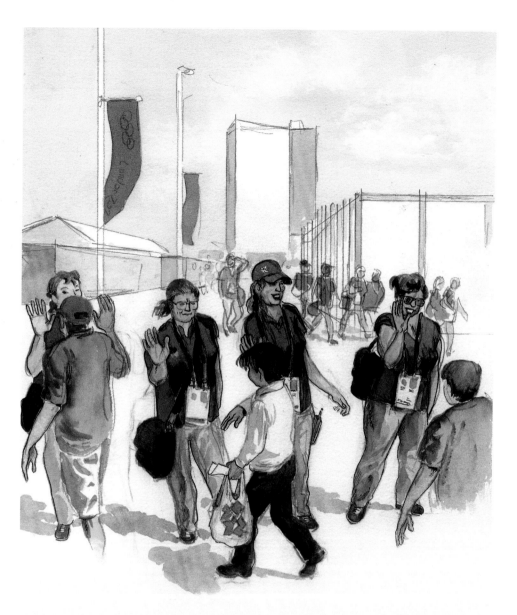
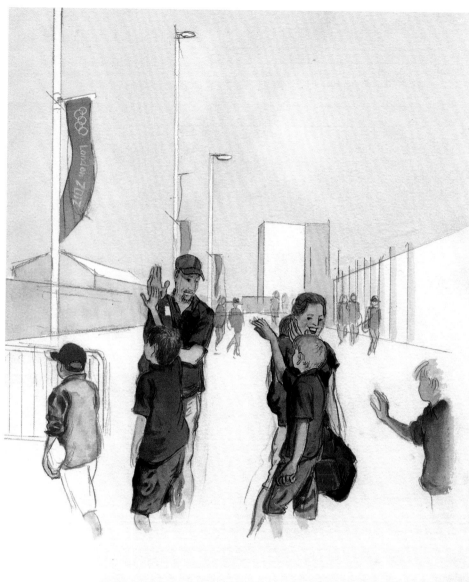

Friendly volunteers welcome excited visitors to the Olympic Park

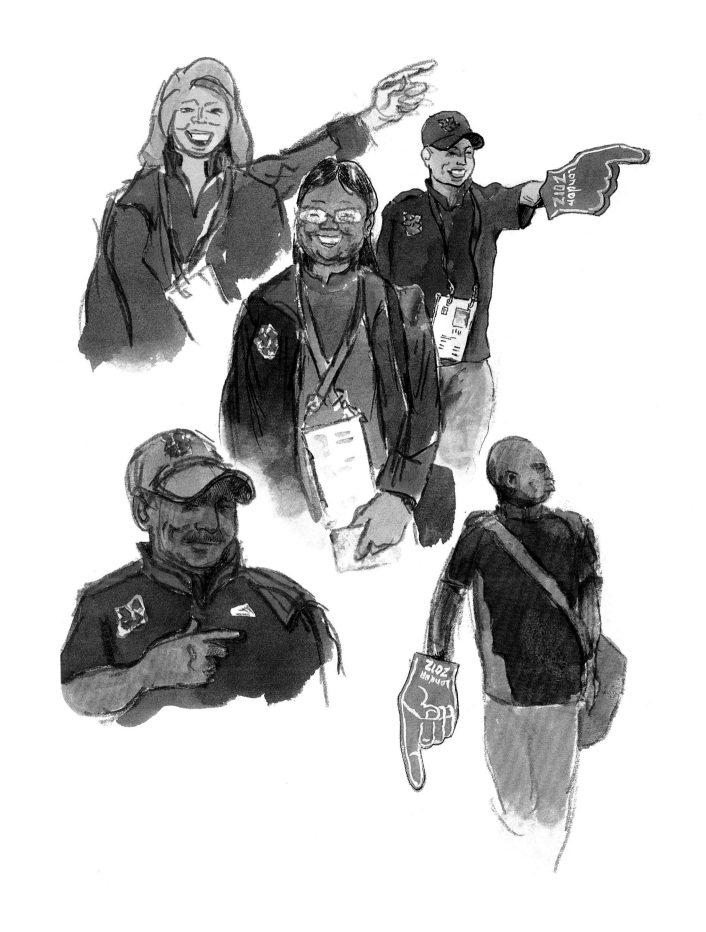

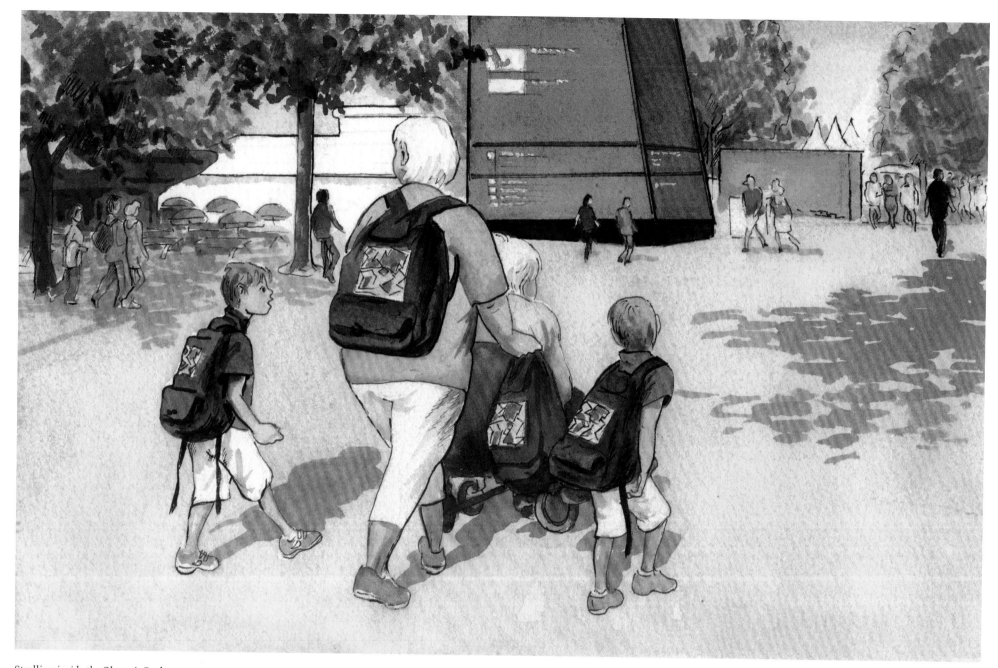

Strolling inside the Olympic Park

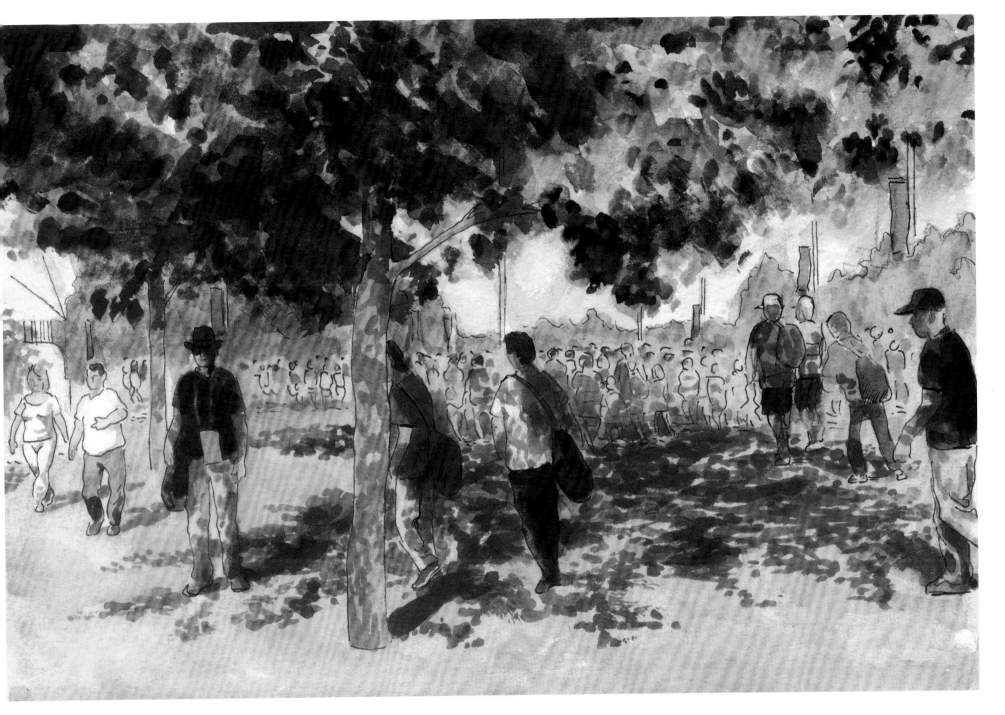

The crowds in the Park

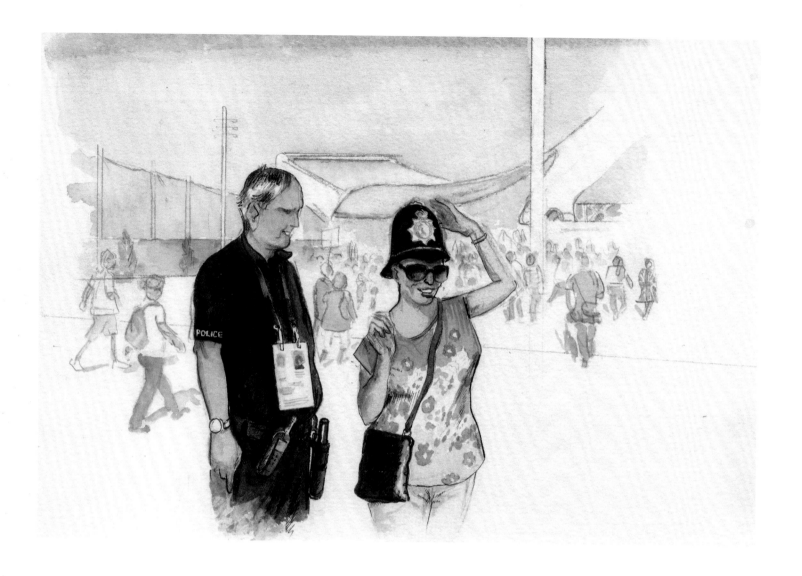

'Policemen and soldiers were often asked to pose for photographs and were always happy to oblige. The two armed policemen rested their guns across their knees and knelt down so not to tower over the child. After the woman had taken the picture, one of the officers took off his cap and put it on the girl's head and said "Take another".'

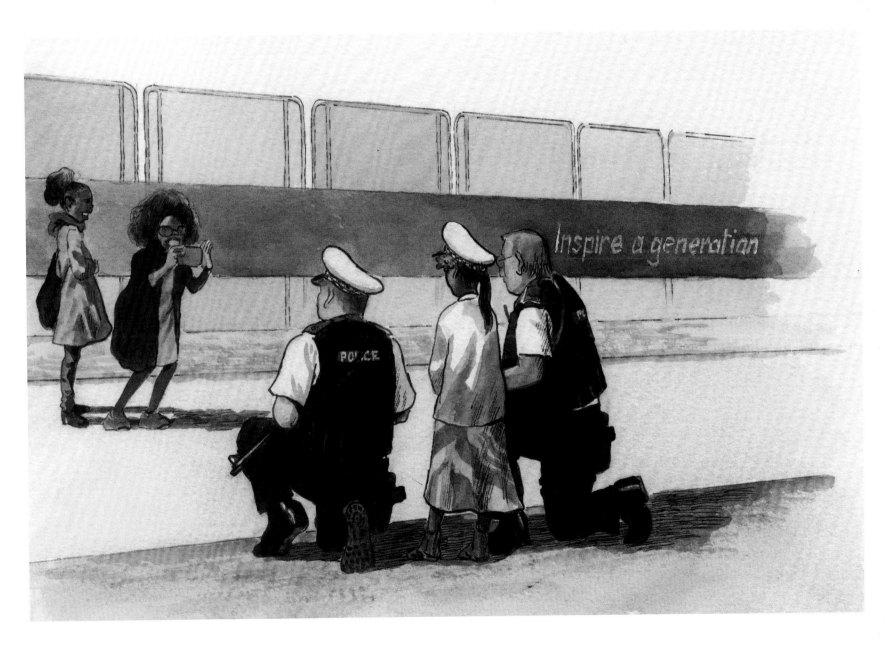

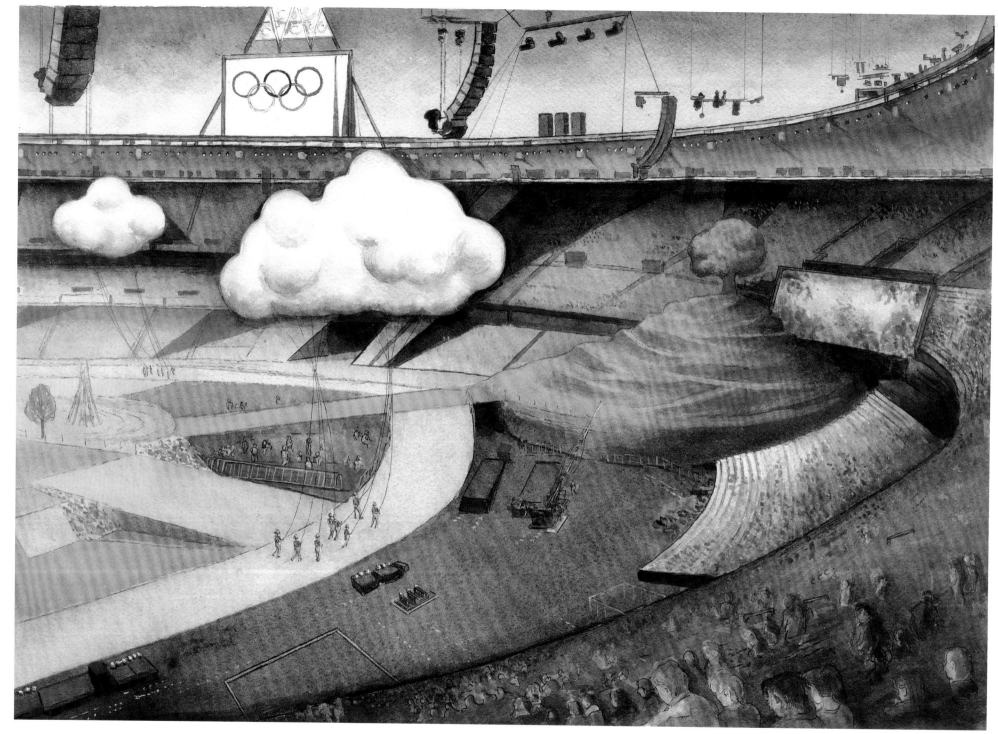

Two scenes from the opening ceremony of the Olympic Games

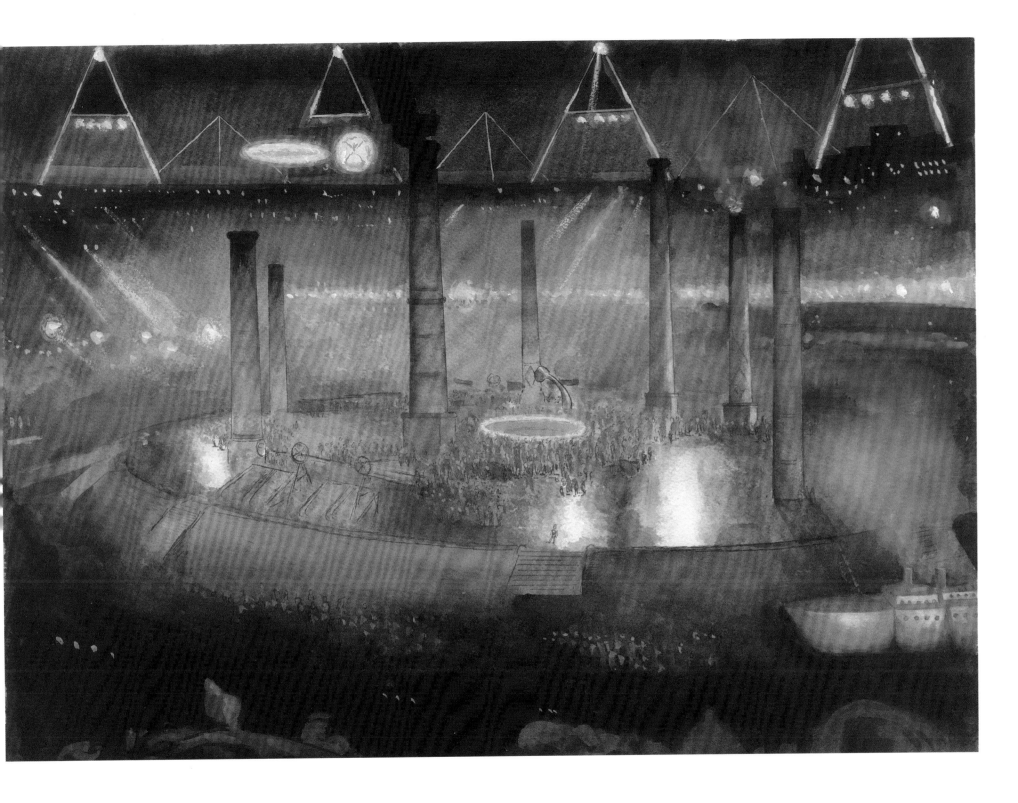

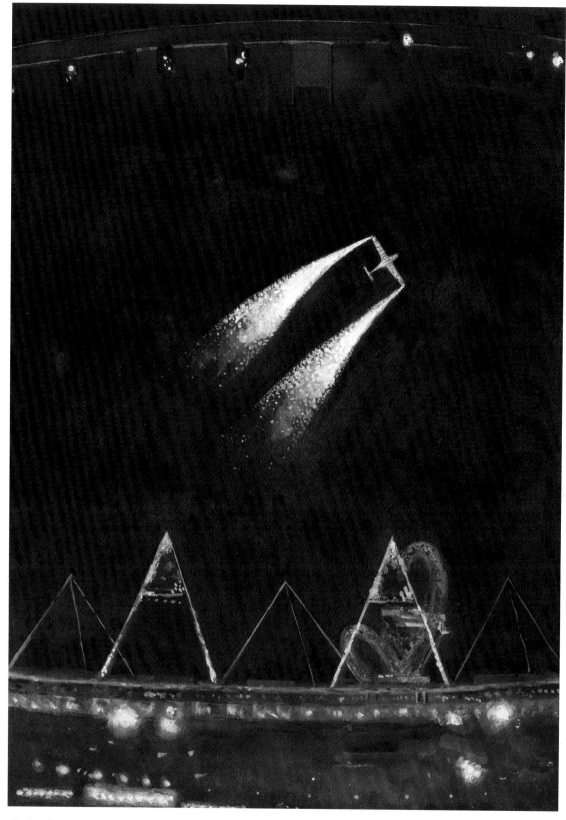

The Paralympics opening ceremony begins against the backdrop of Anish Kapoor's ArcelorMittal Orbit in the night sky

'The opening ceremony of the Paralympic Games was superb and began with a brilliant *coup de théâtre*. Out of the night sky an aeroplane roared over the arena like a comet trailing fire from its wing tips.'

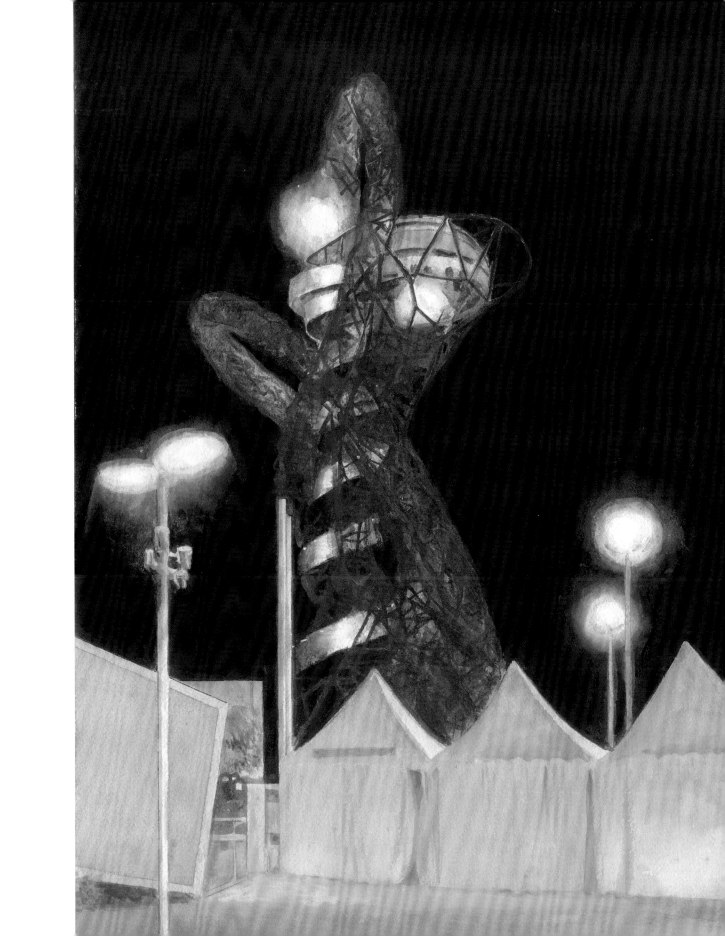

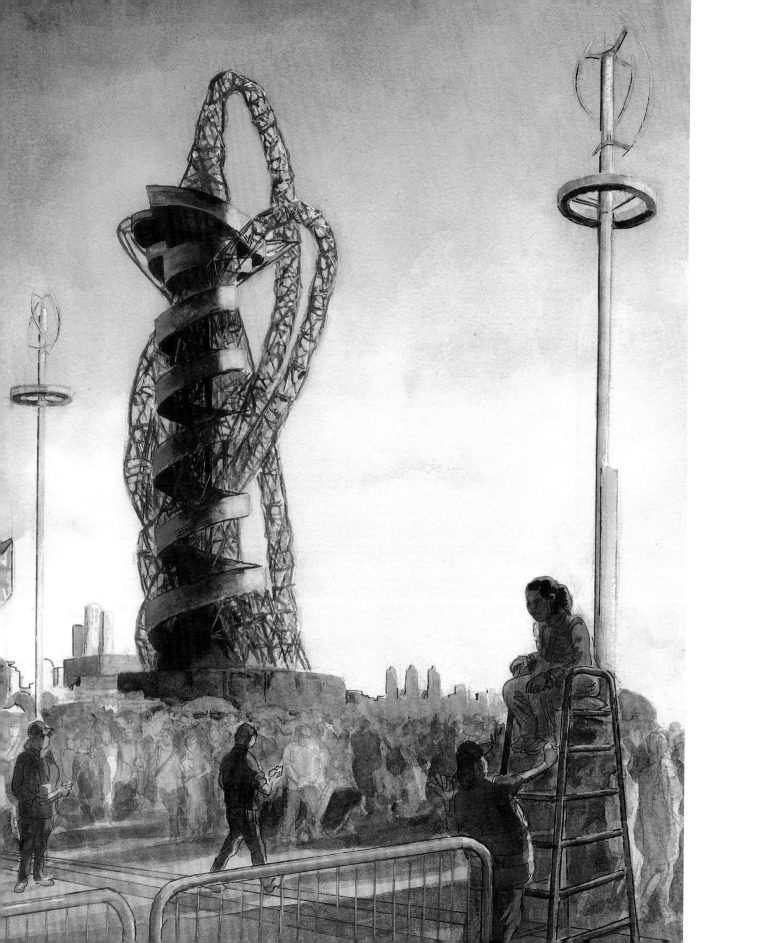

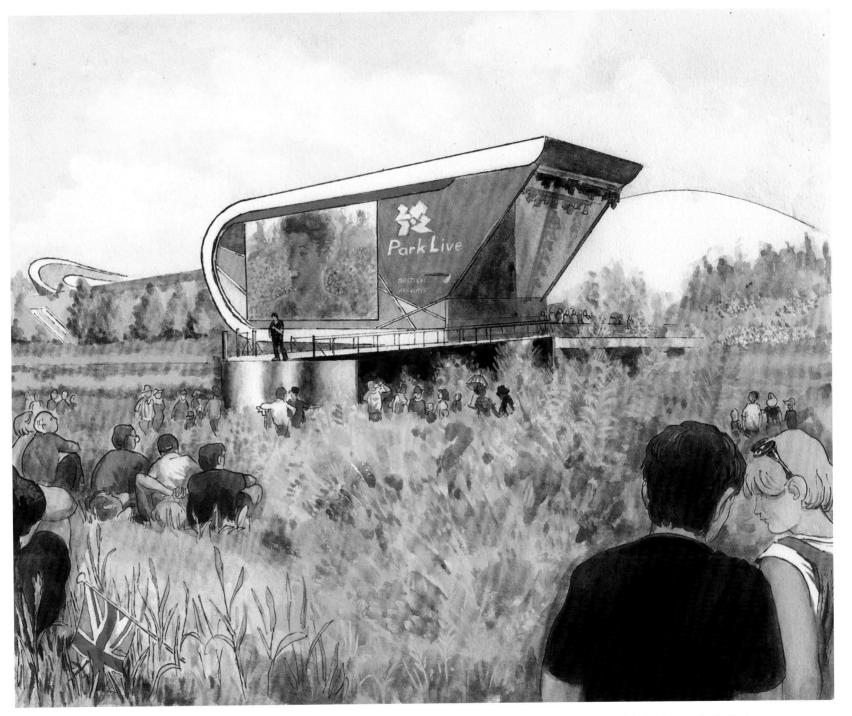

Spectators prepare to watch the events on a giant 'Park Live' screen in the Olympic Park, where they could see the Games live or catch highlights from earlier in the day

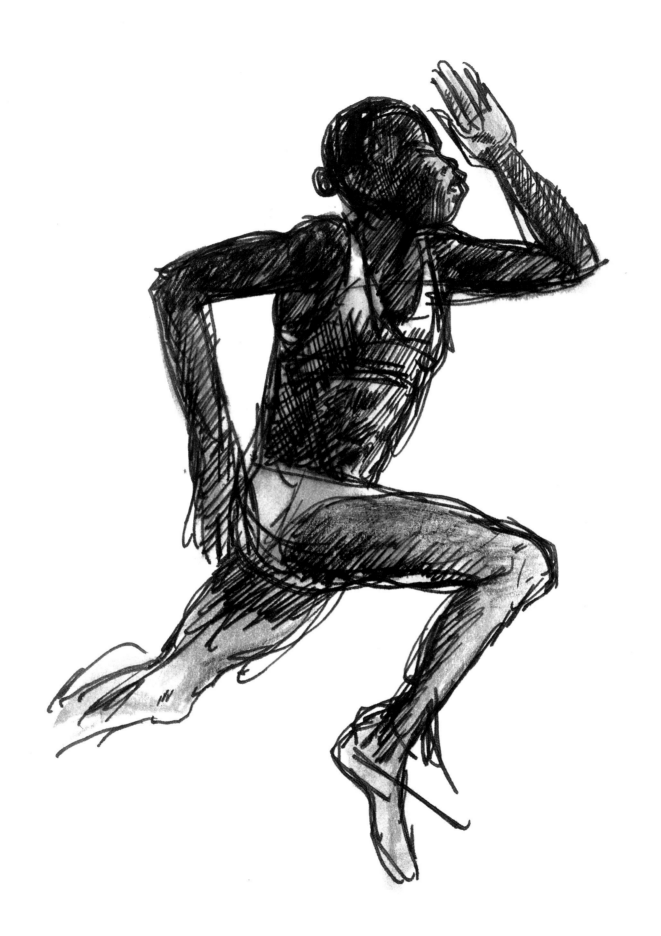

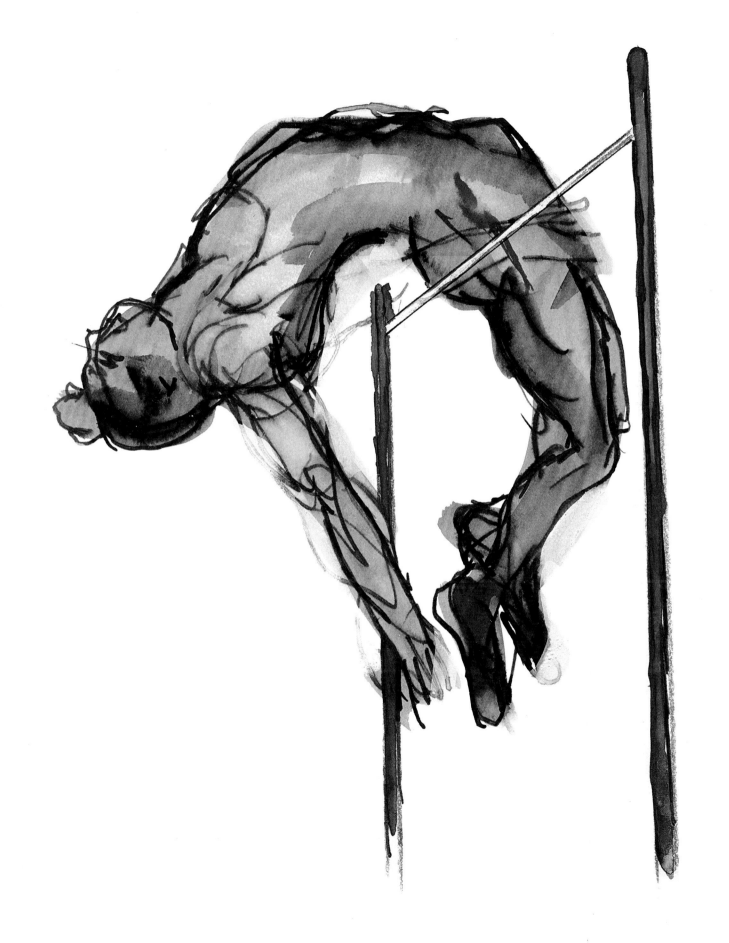

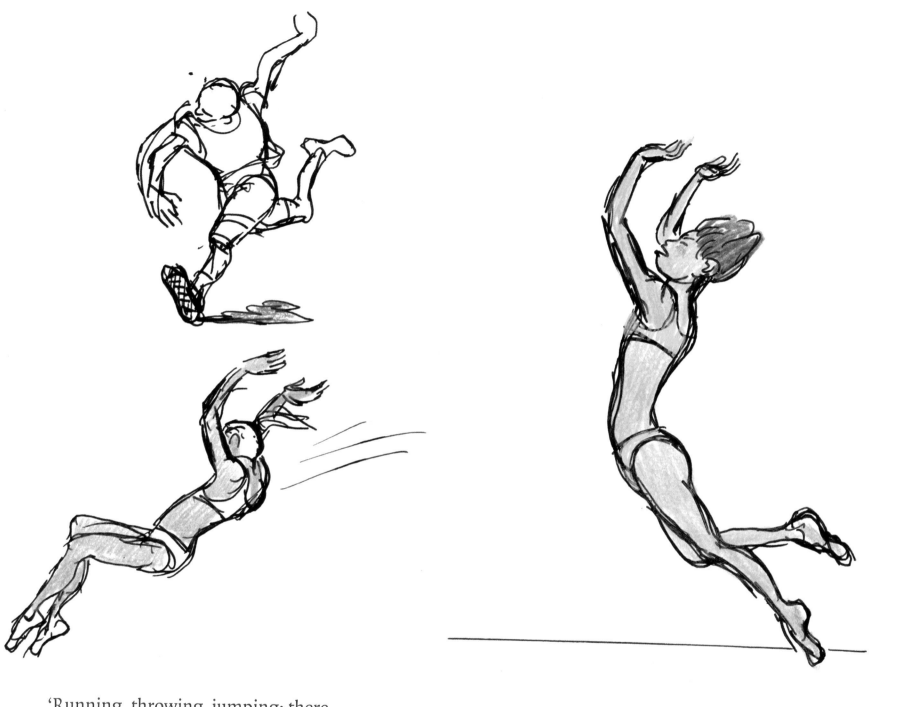

'Running, throwing, jumping: there was always plenty to watch inside the Olympic Stadium.'

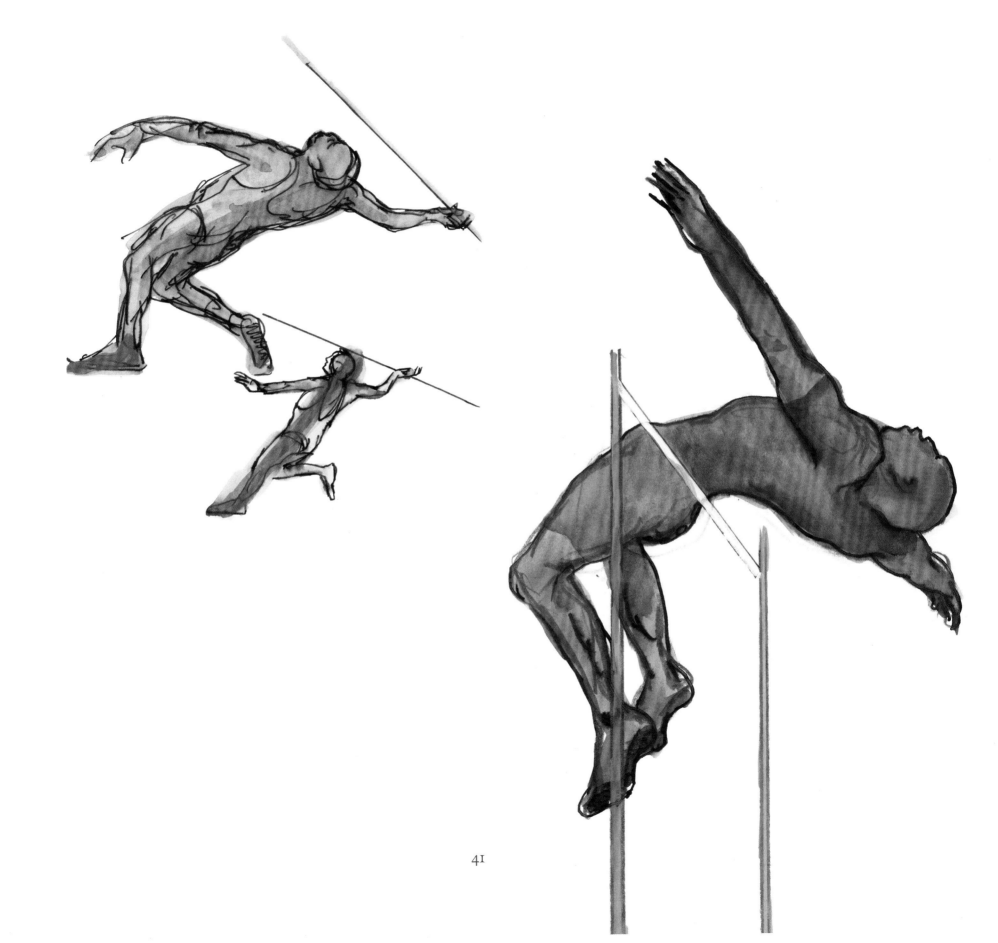

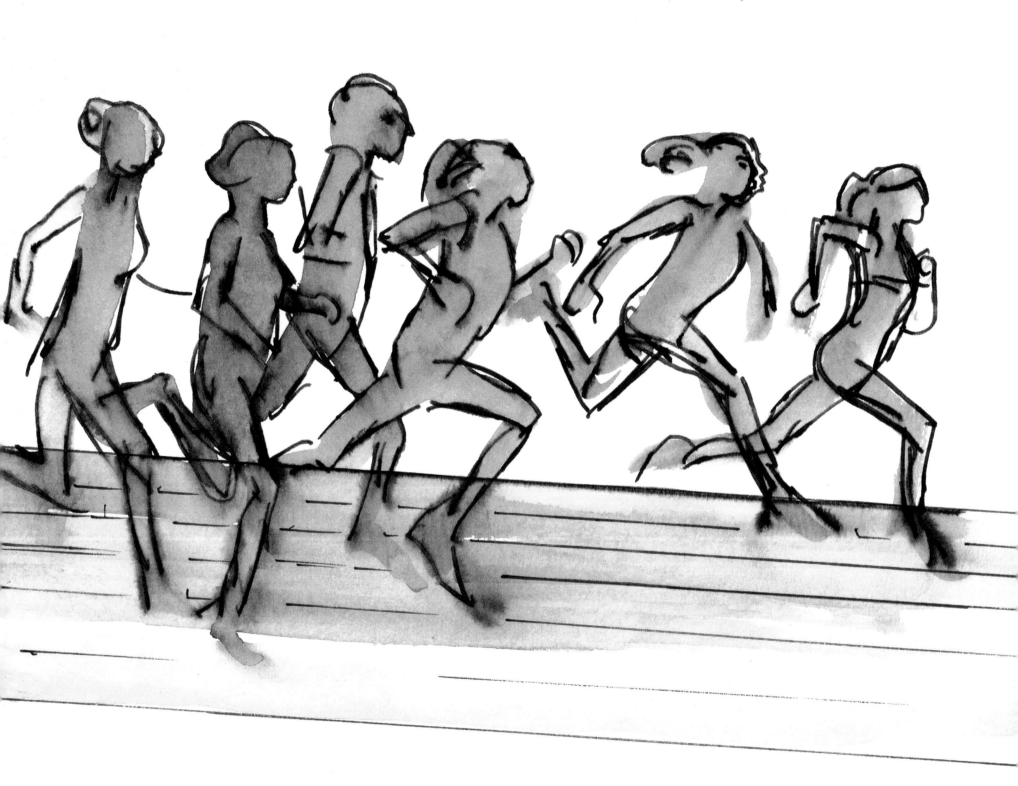

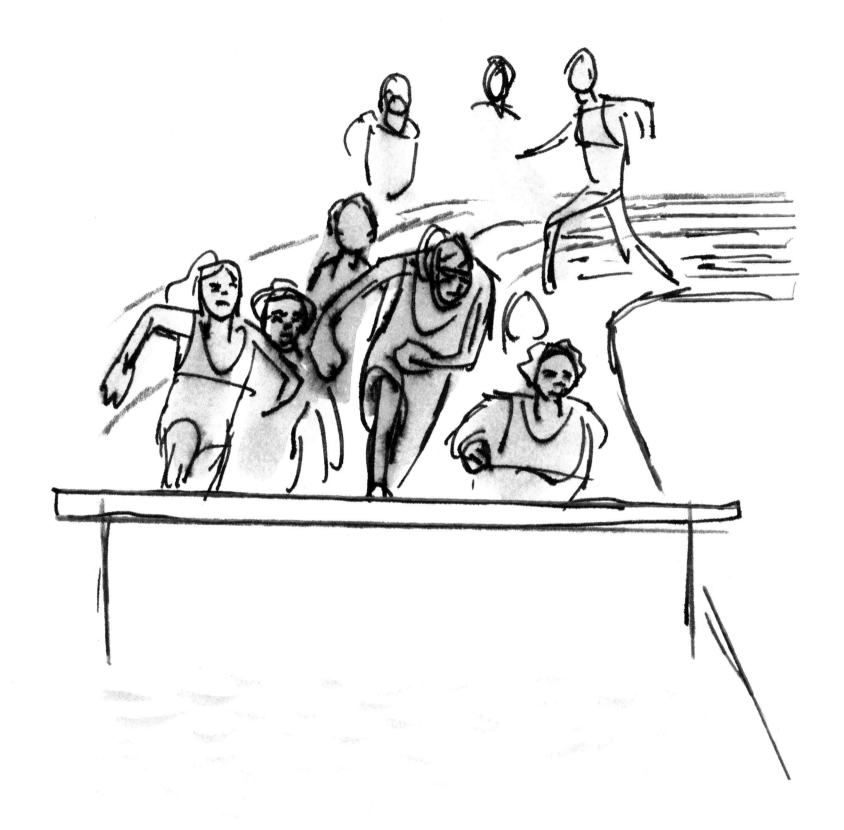

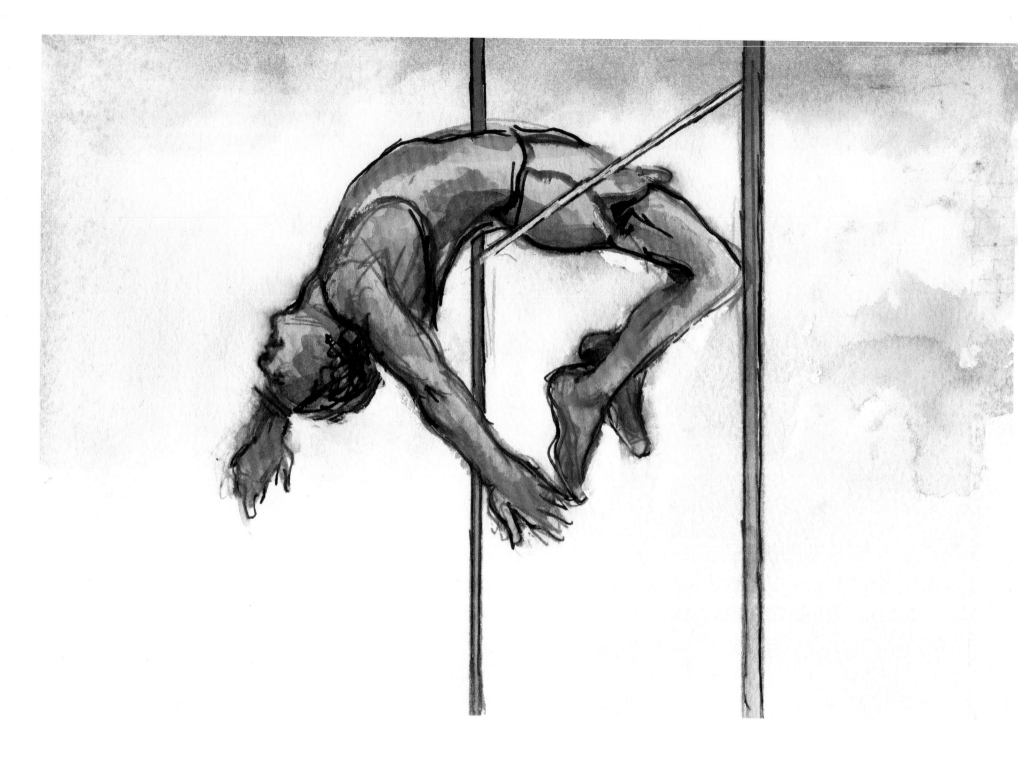

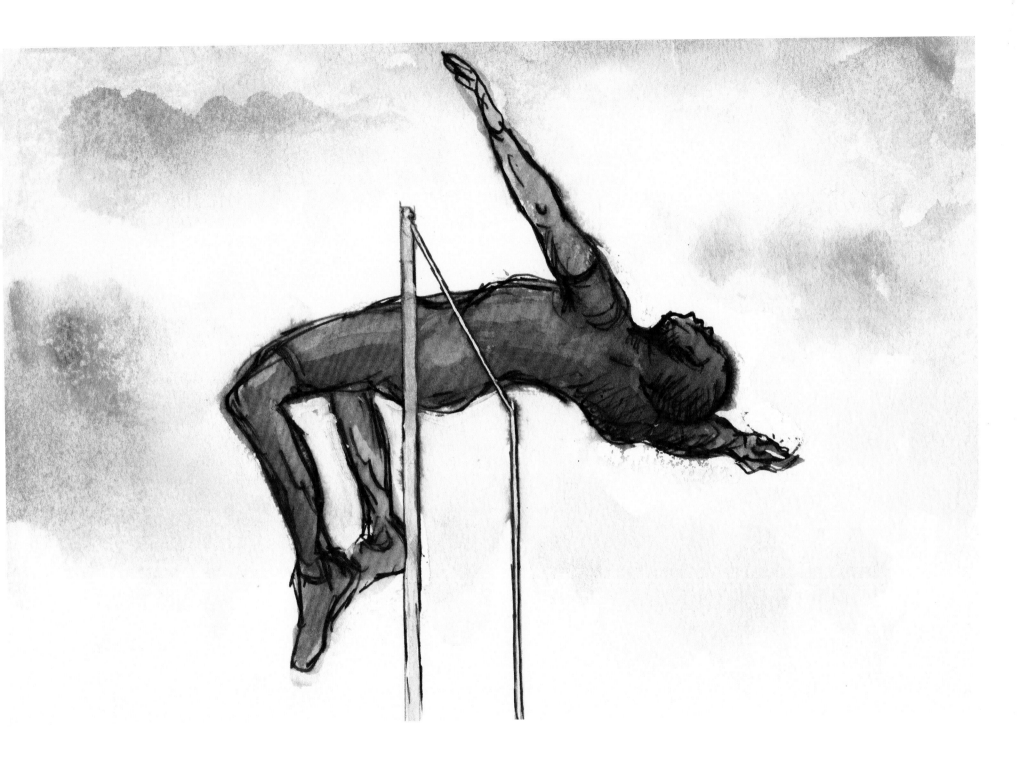

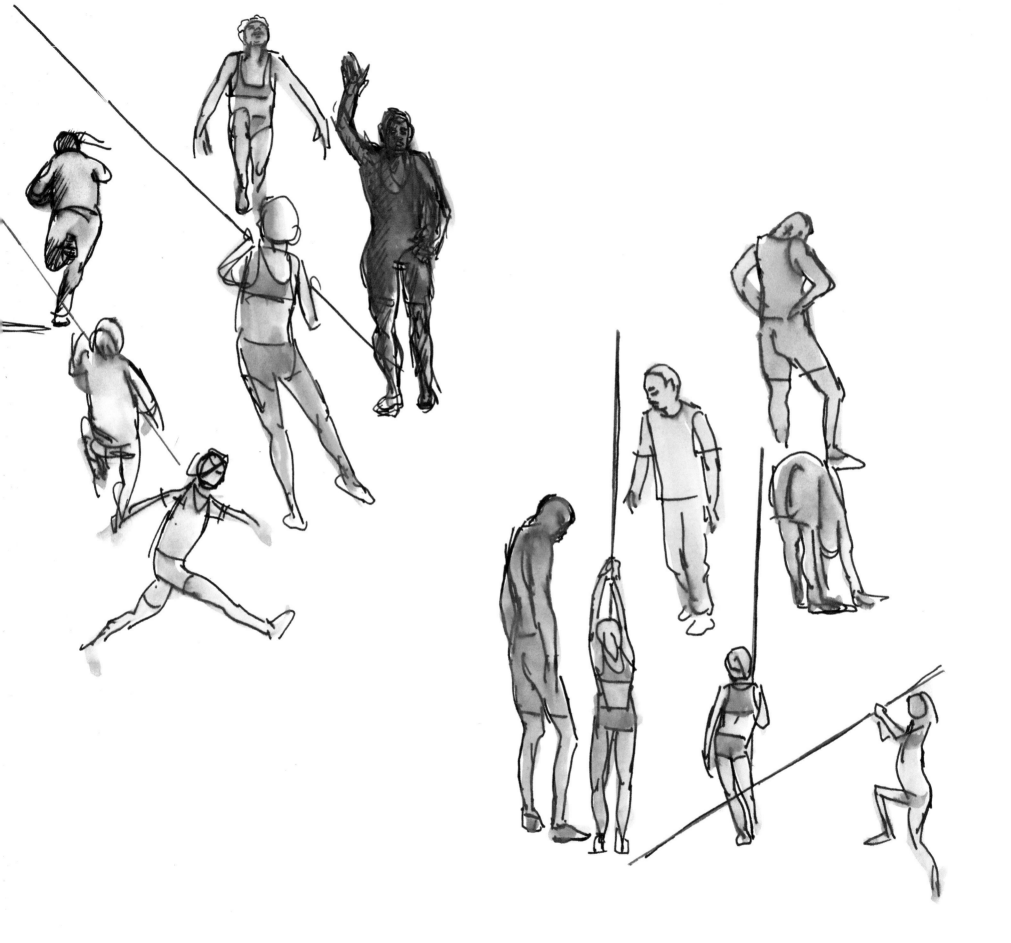

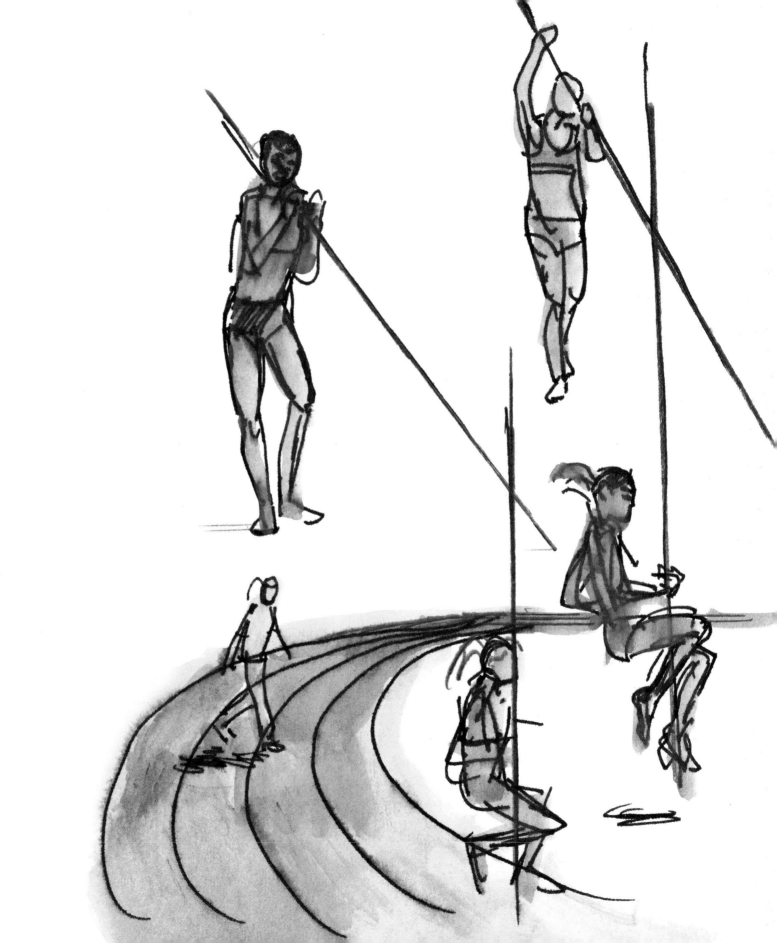

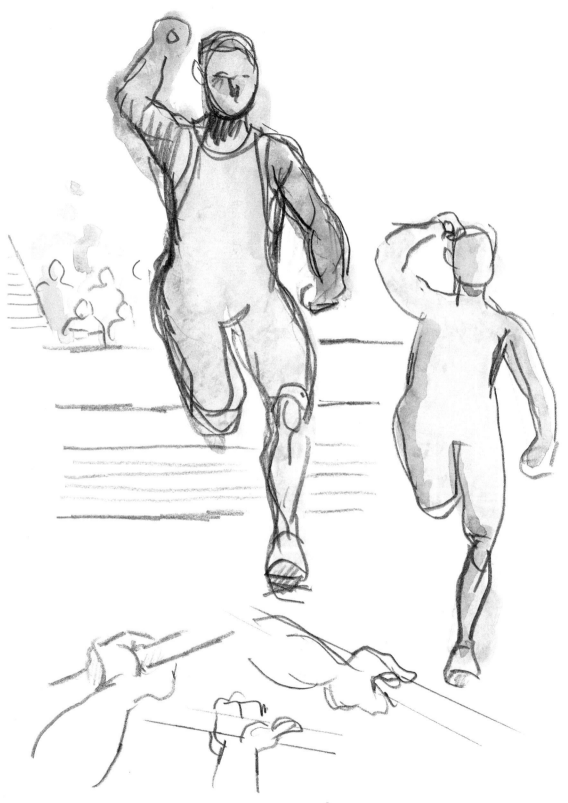

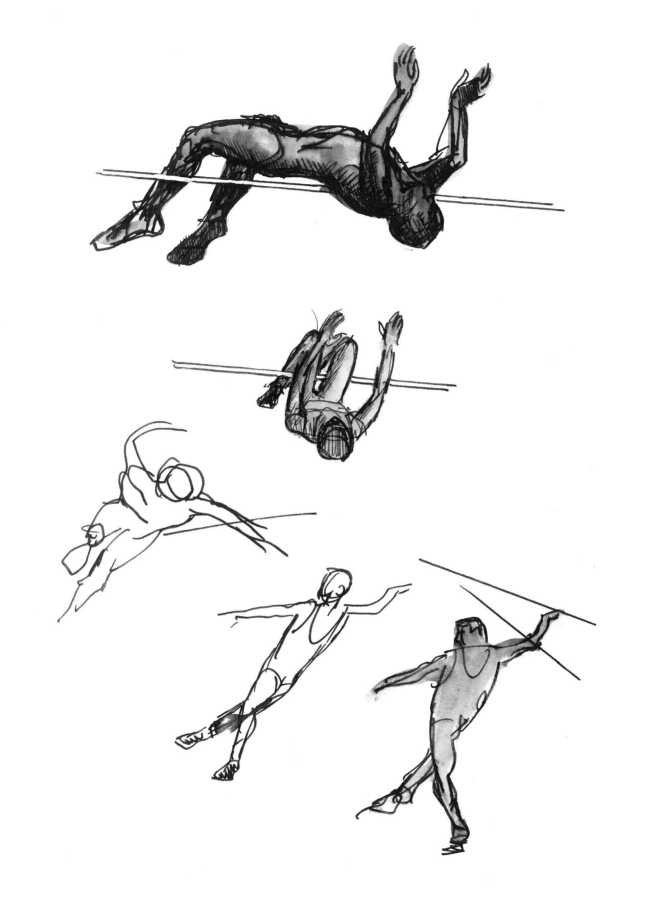

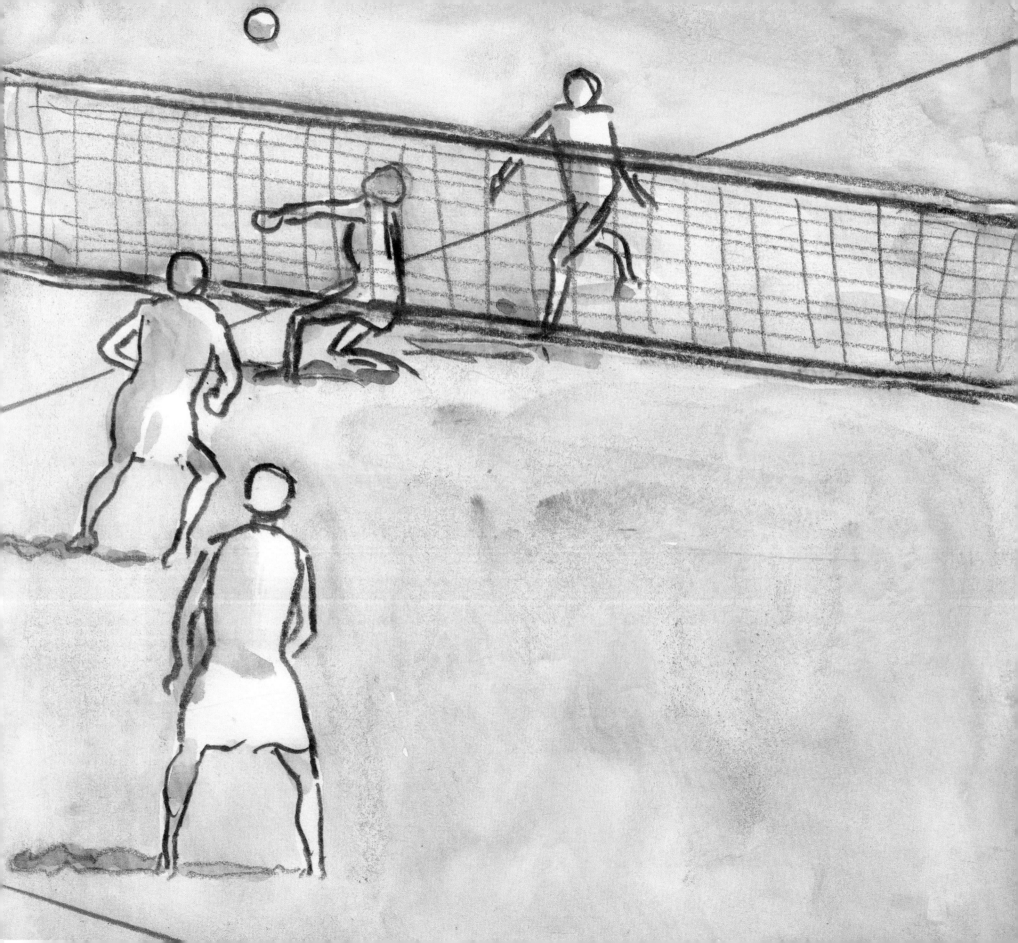

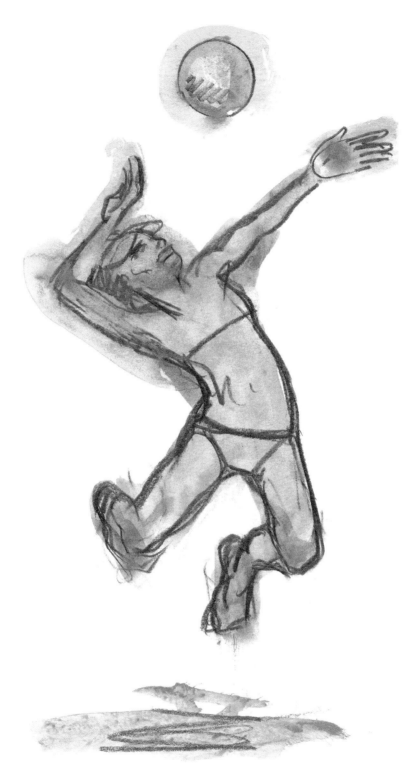

Away from the Park: beach volleyball at Horse Guards Parade

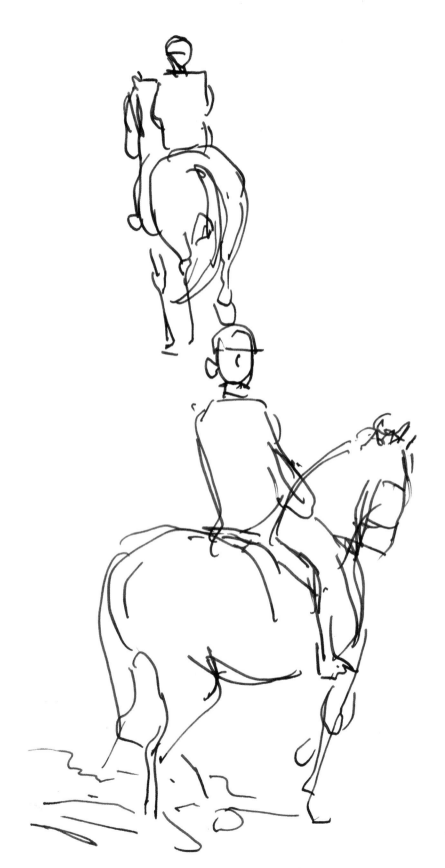
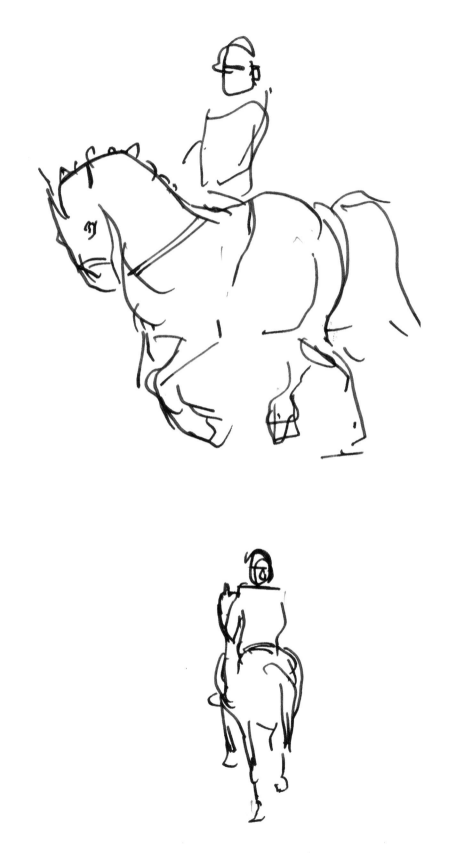

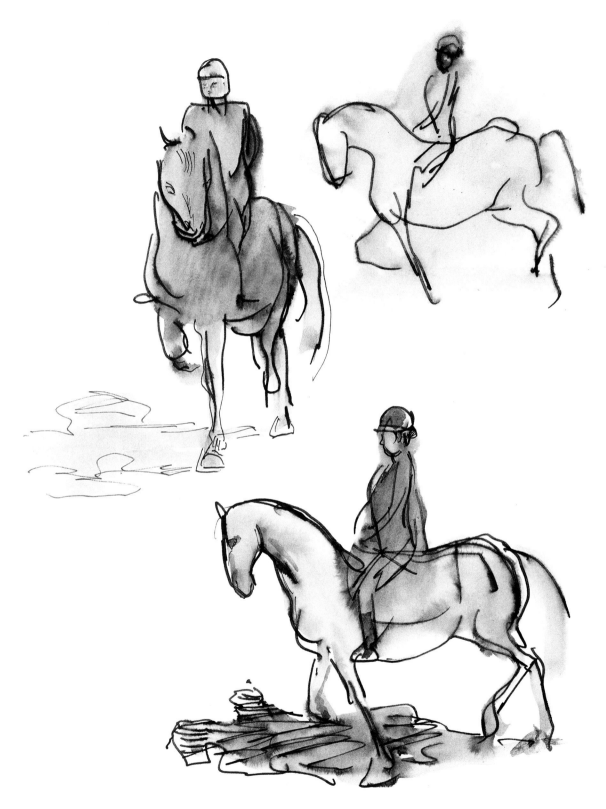

Equestrian events in Greenwich Park (opposite and above)

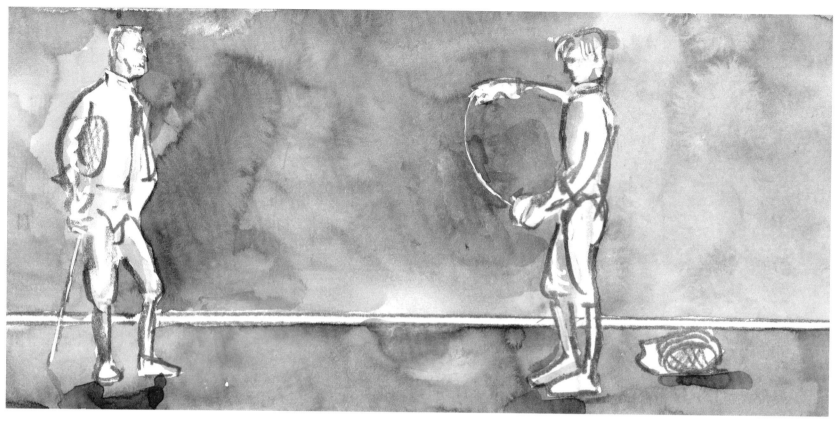

Fencing at the ExCel Arena

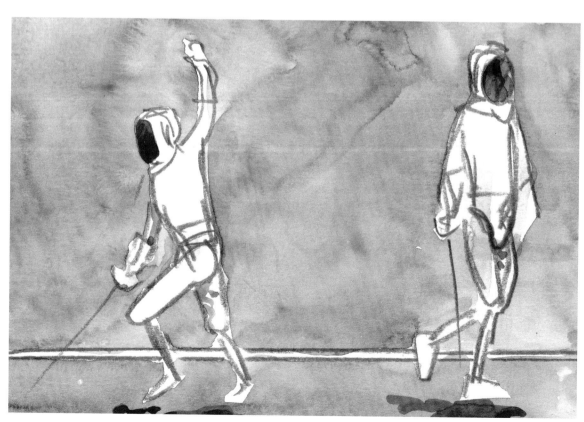

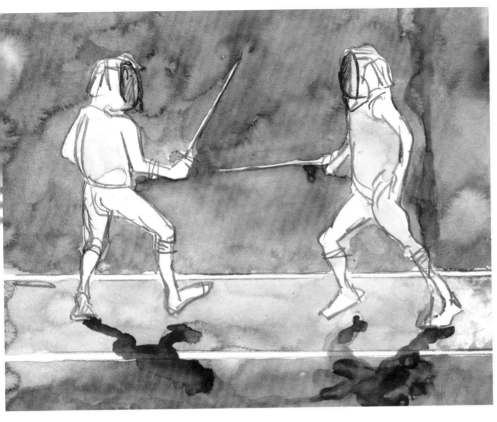

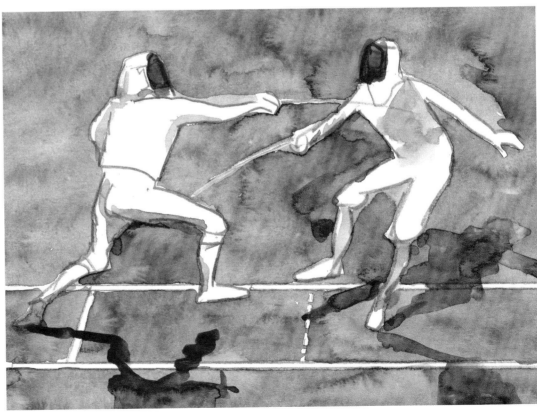

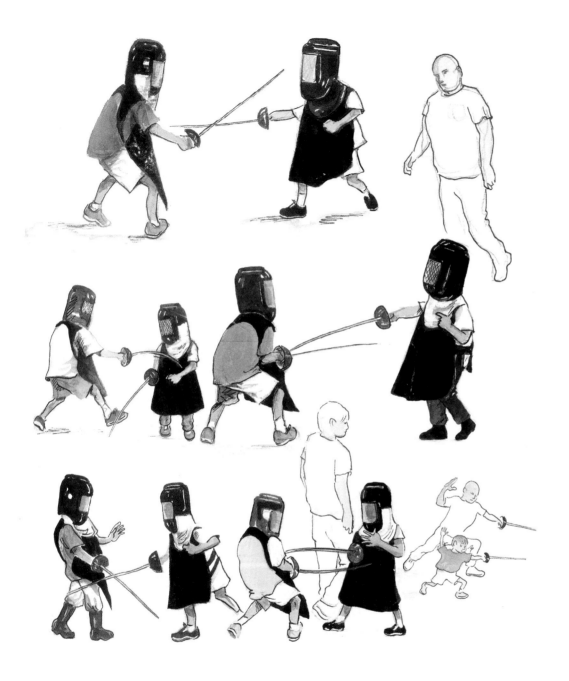

'Outside the fencing venue at ExCel, an area was set aside where children were instructed in the basic skills of the sport. They wore protective helmets and aprons and were armed with plastic foils.'

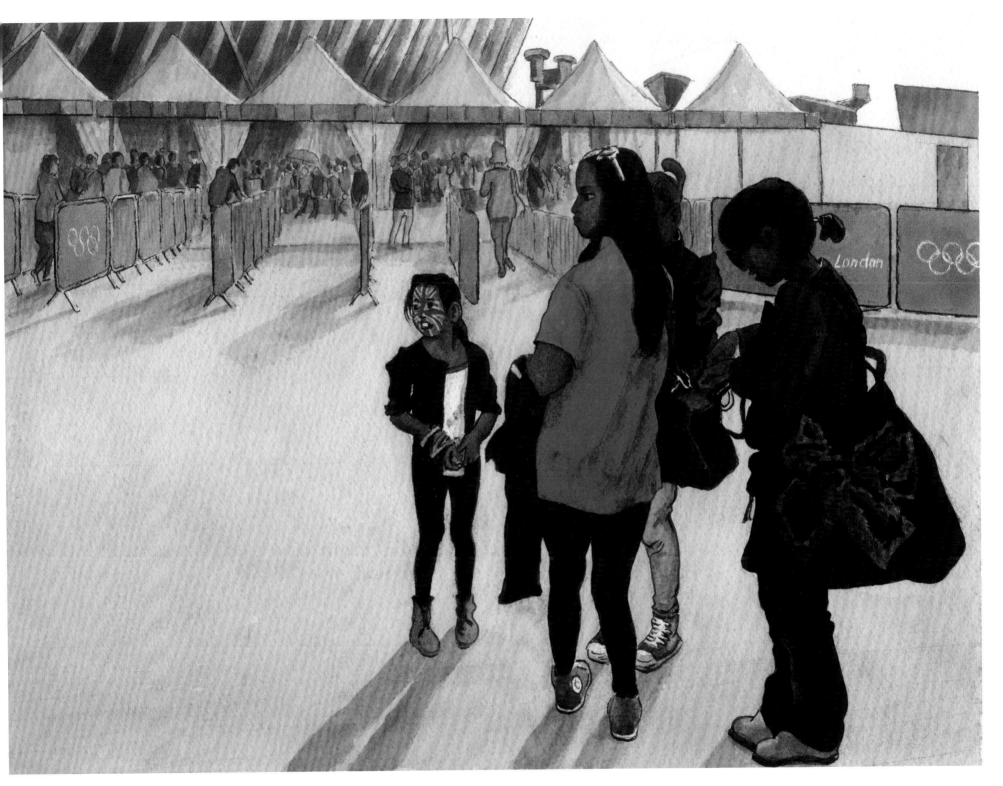

A little girl outside the Olympic Stadium with a Union Jack painted on her face

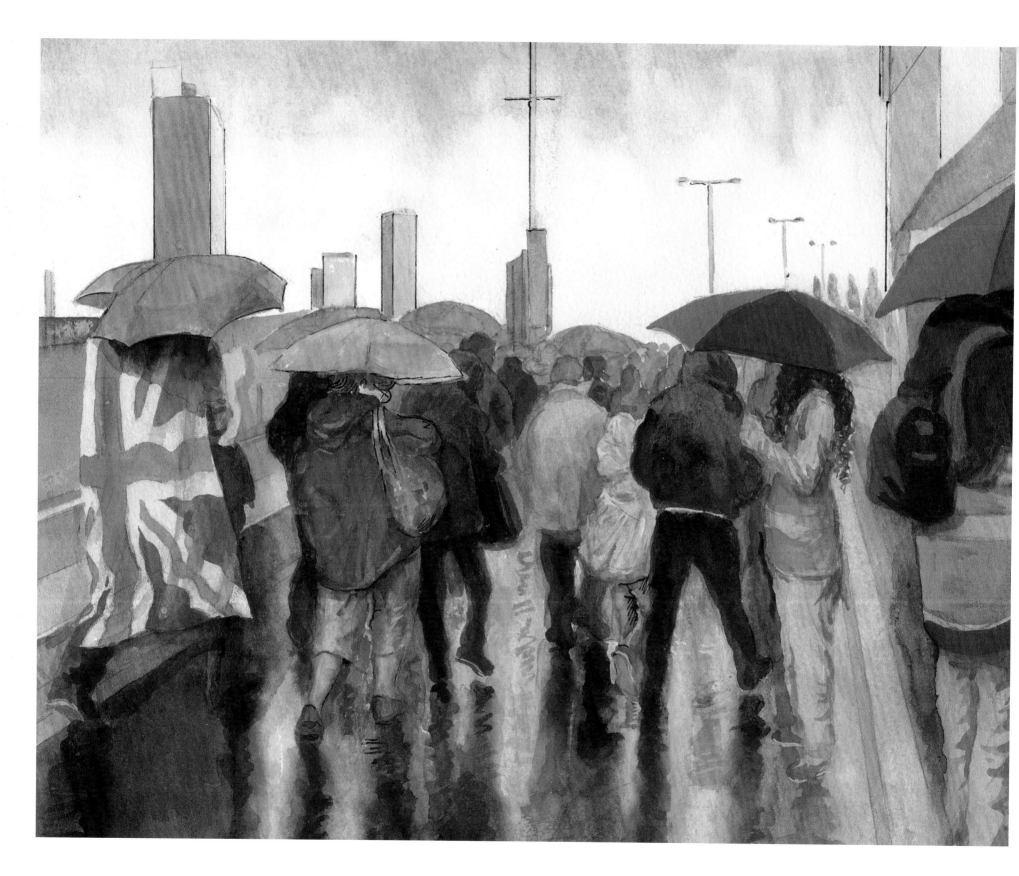

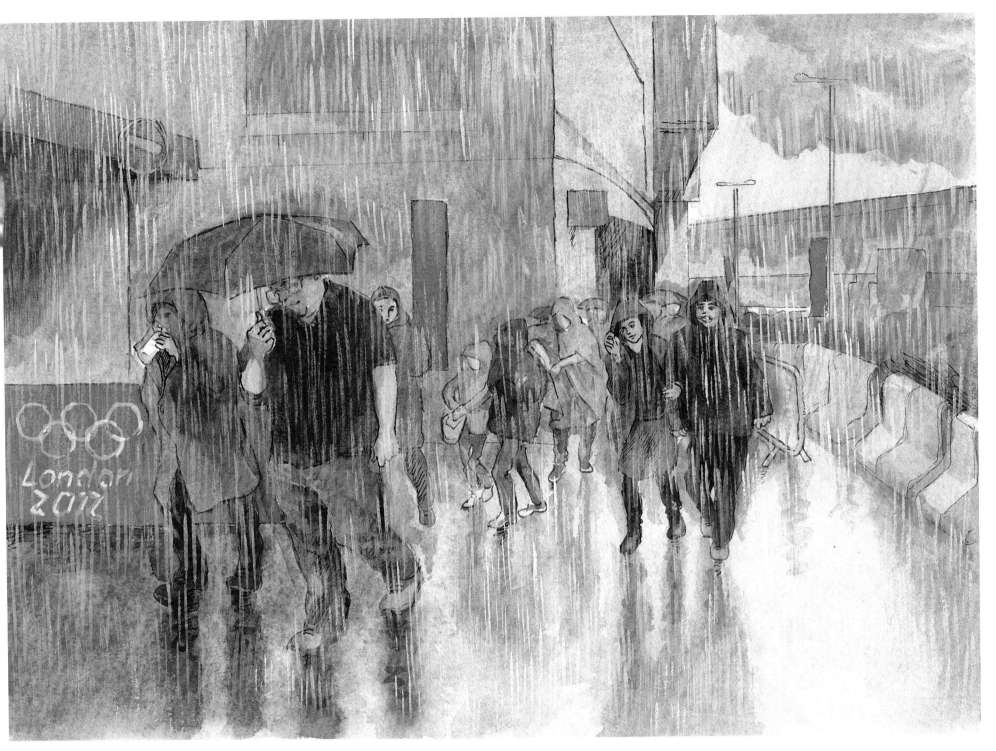

Occasional rain showers did nothing to deter the enthusiastic fans pouring into the Olympic Park

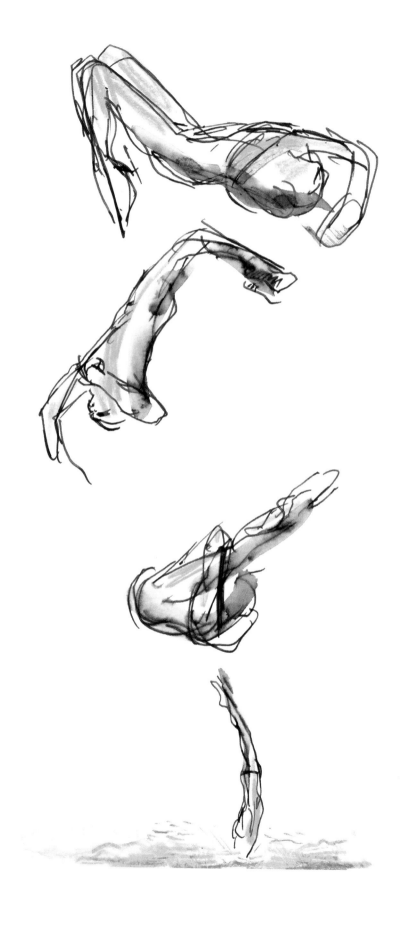

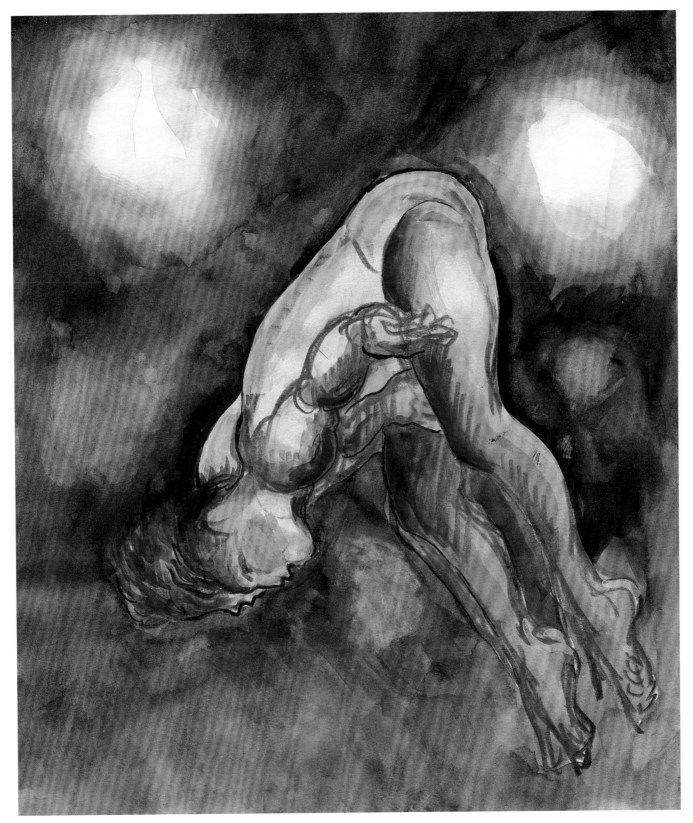

Solo diving (opposite) and synchronised diving (above) in the Aquatics Centre of the Olympic Park

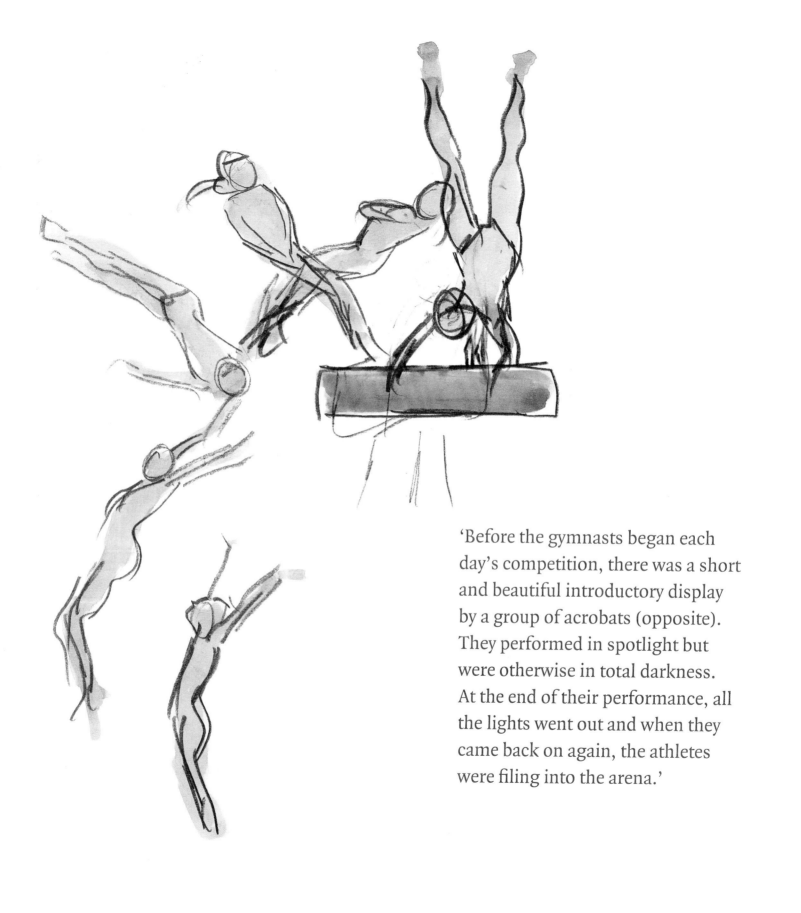

'Before the gymnasts began each day's competition, there was a short and beautiful introductory display by a group of acrobats (opposite). They performed in spotlight but were otherwise in total darkness. At the end of their performance, all the lights went out and when they came back on again, the athletes were filing into the arena.'

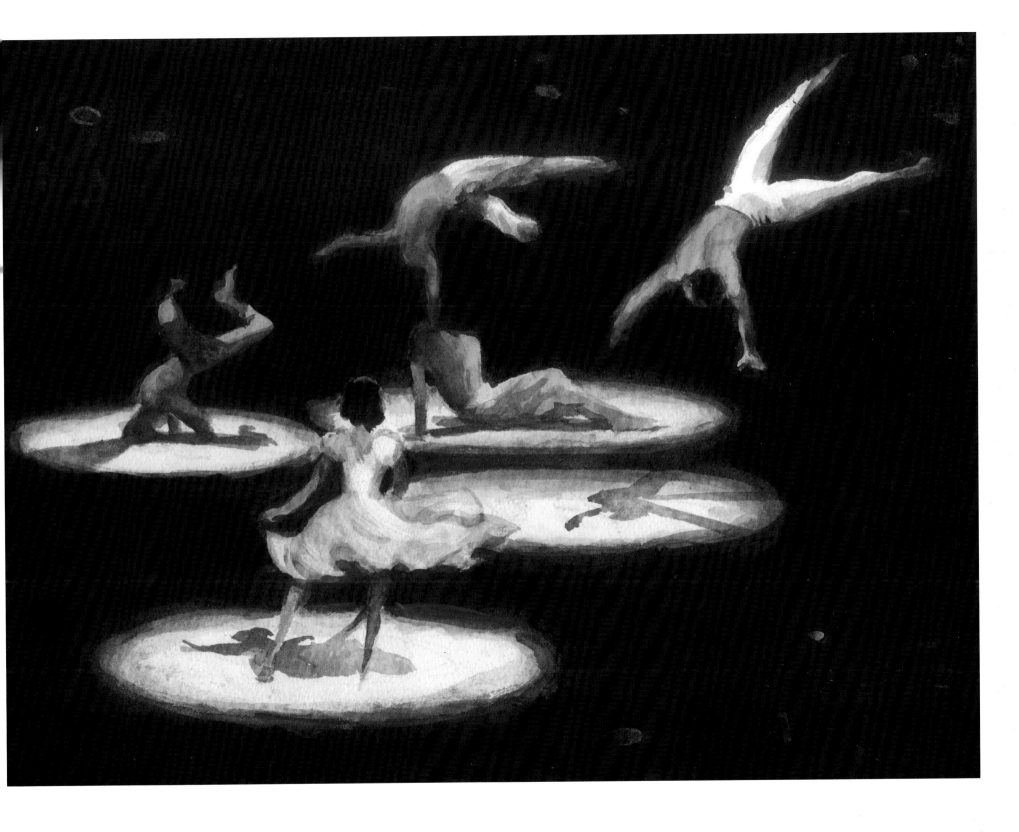

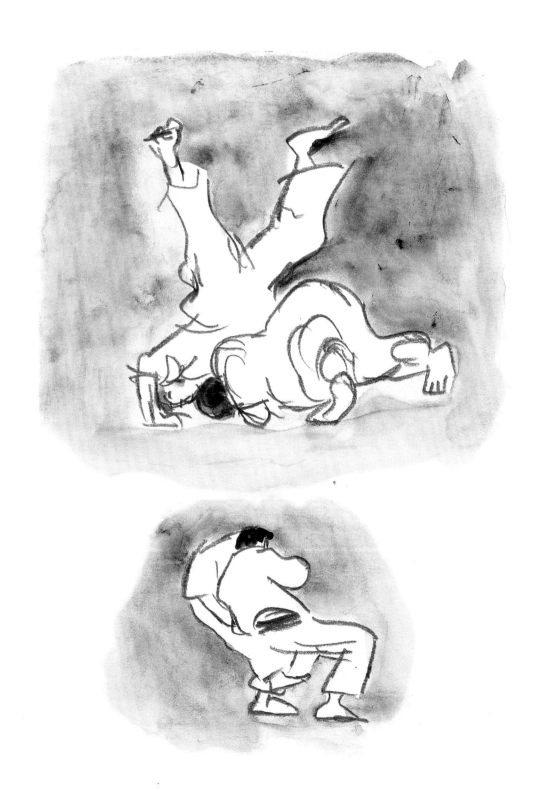

Judo in the ExCel Arena

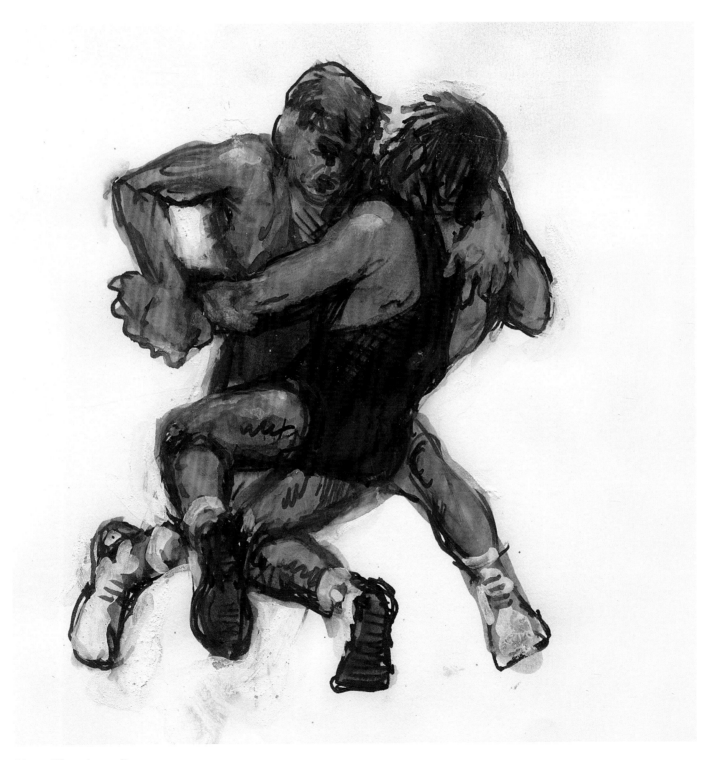

A bout of freestyle wrestling

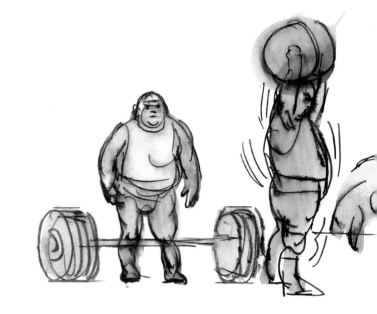

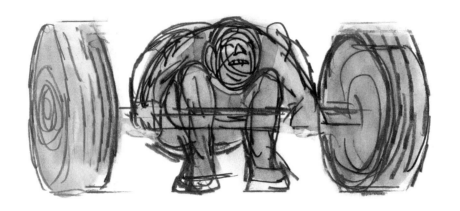

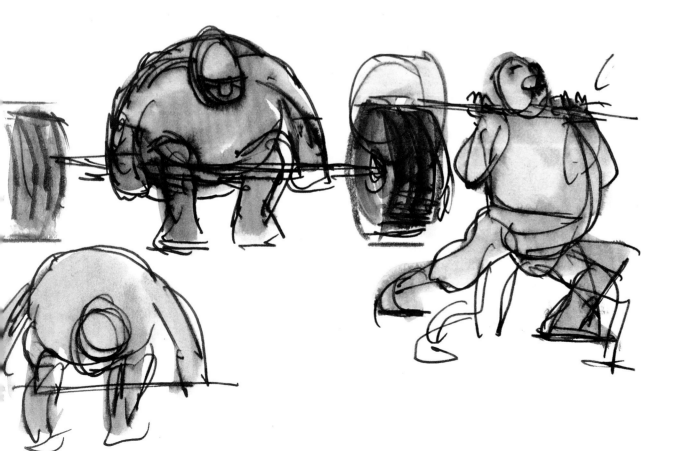

'After each weightlifter left the stage, two men stepped forward to reposition the weights ready for the next competitor. The two of them working together strained to shift the bar a few inches – the bar we had just seen one man raise above his head.'

'Where next?'

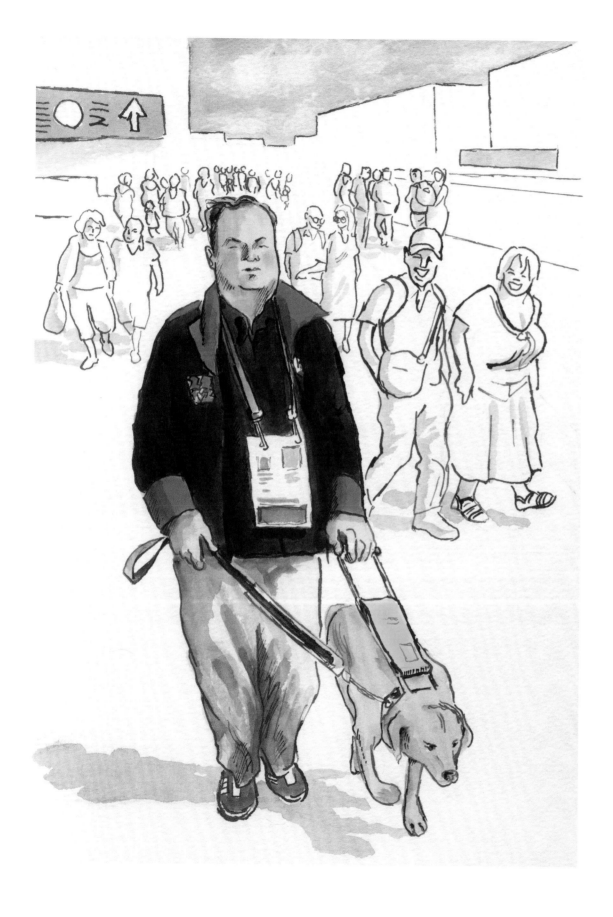

'The volunteers came from all walks of life and put themselves at the service of anyone who needed directions or assistance. Everyone felt great affection for them and learned to depend on and respect their tireless willingness to help. They became one of the great successes of the Games.'

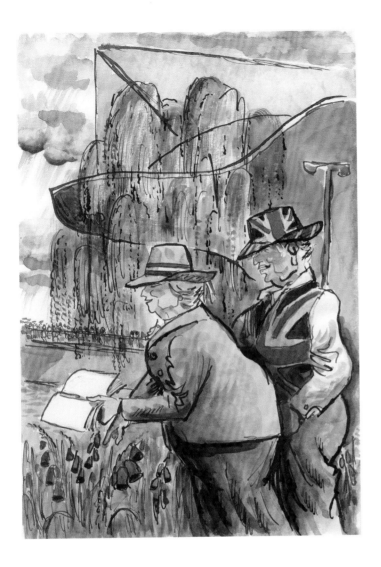

'One day, I saw this couple dressed in patriotic outfits examining one of the many lovely flower beds that were placed all over the Olympic Park. With exquisite timing, these gardens bloomed just as the Games opened and the first people began to flood in.'

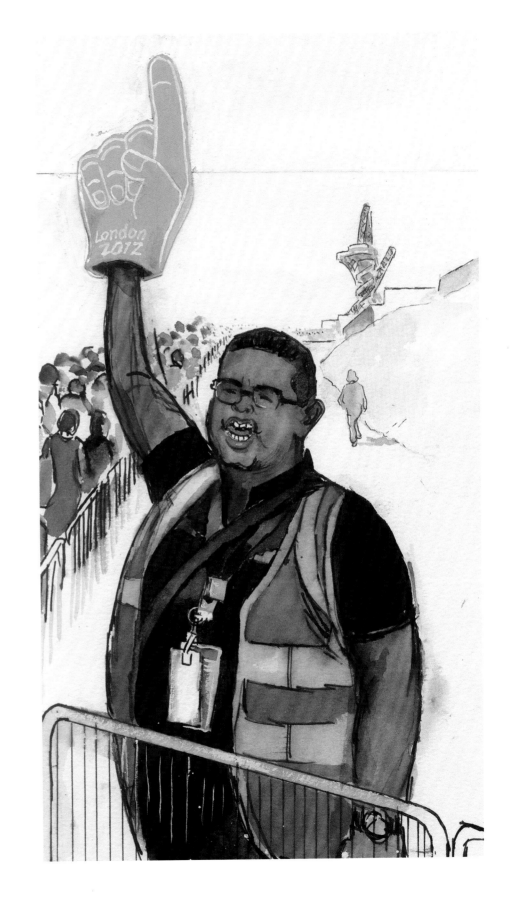

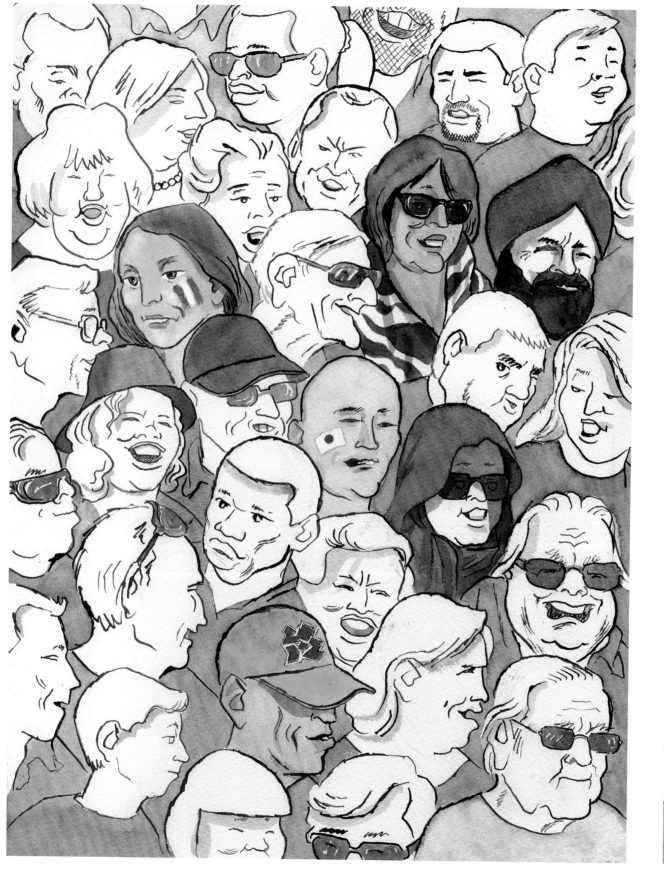

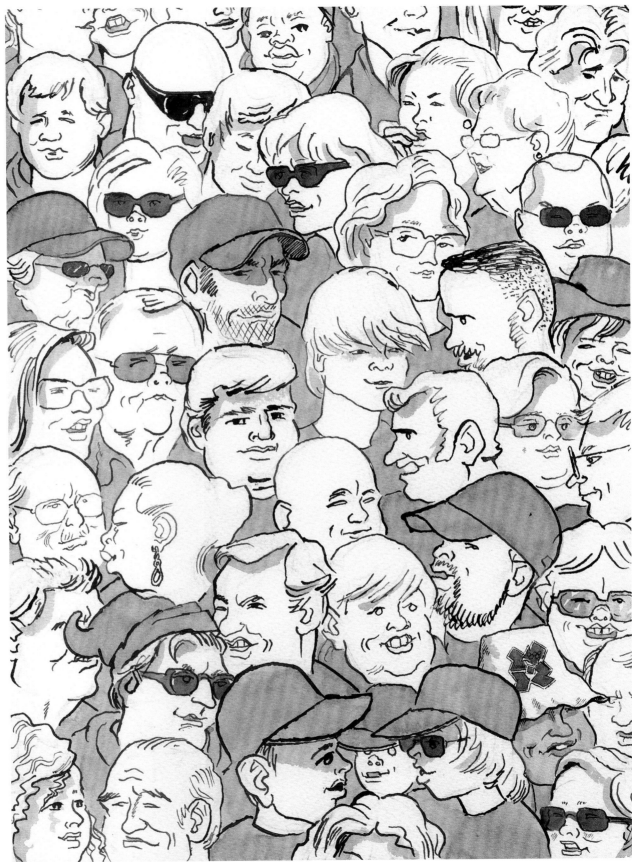

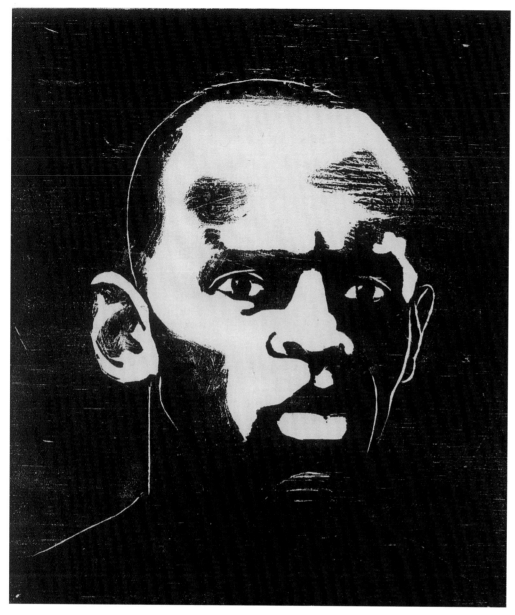

Usain Bolt, men's 100m, 200m and 4 x 100m relay gold

'I had always intended to make woodcut portraits of some of the heroes of the Olympic and Paralympic Games and in the event included one of the volunteers.'

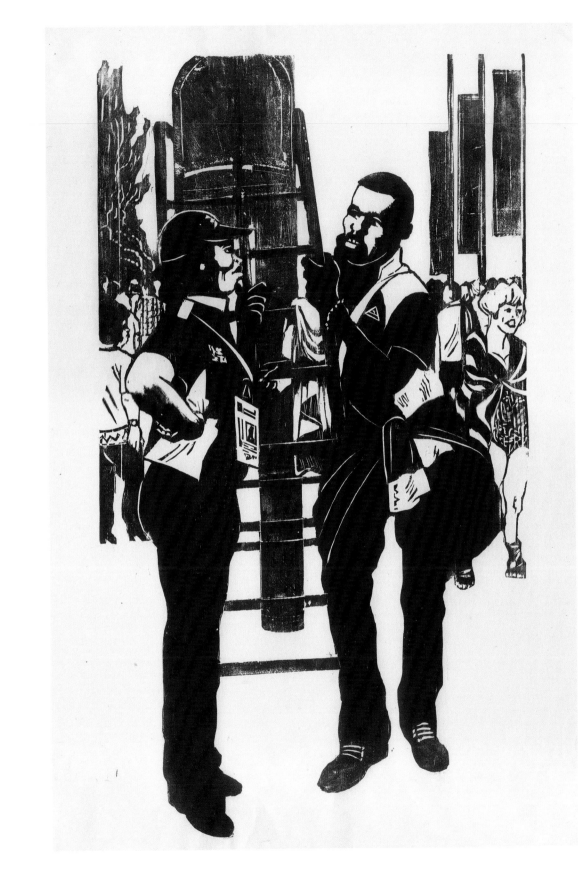

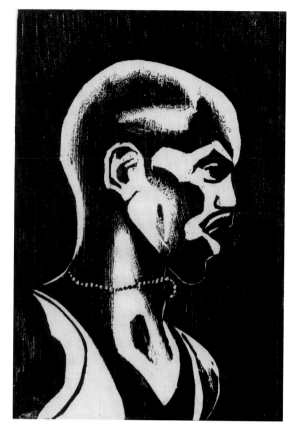

Mo Farah, men's 5,000m and 10,000m gold

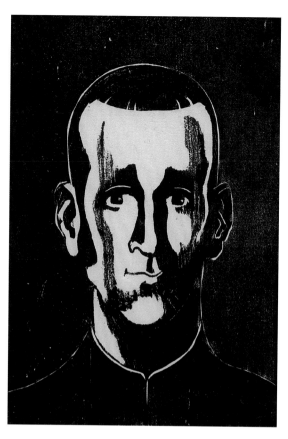

Bradley Wiggins, men's individual time trial gold

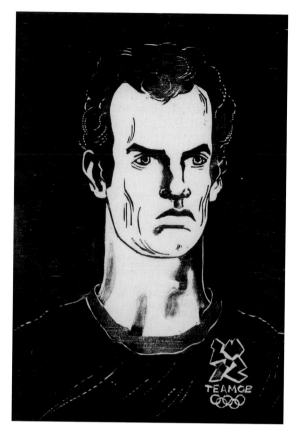

Andy Murray, men's tennis gold

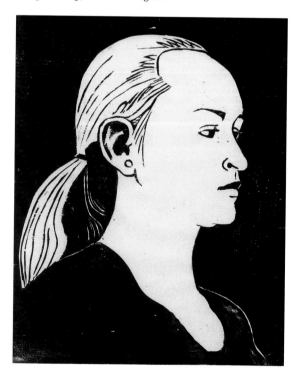

Jessica Ennis, women's heptathlon gold

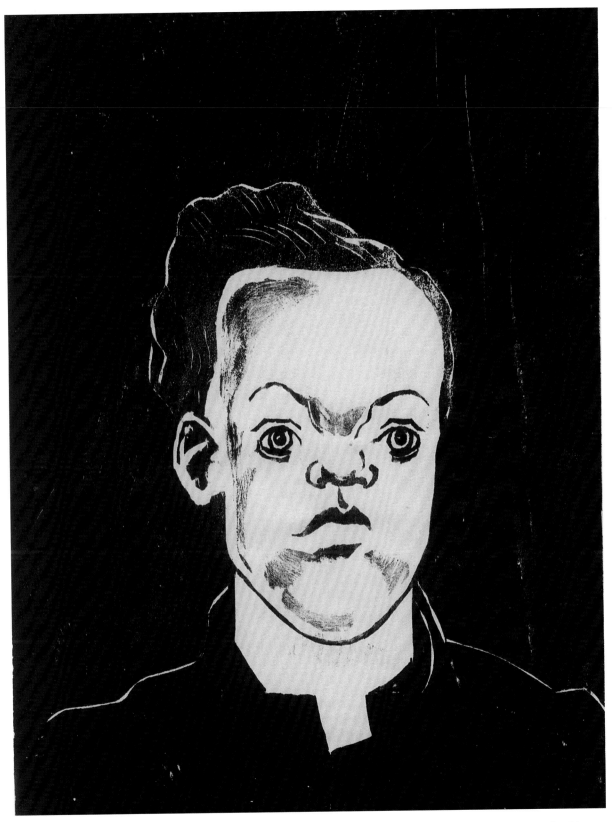

Ellie Simmonds, 400m freestyle S6 and 200m individual medley SM6 gold; 100m freestyle S6 silver; and 50m freestyle S6 bronze

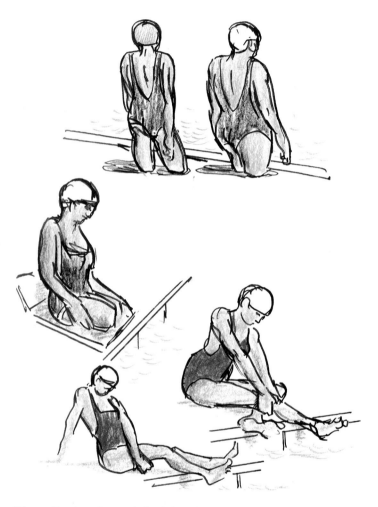

A swimmer getting out of the pool after competing

Women Paralympians wait for their swimming event in the Aquatics Centre

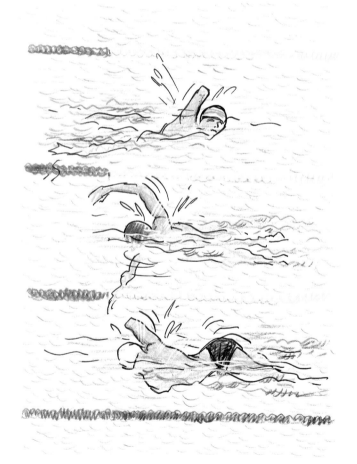

Men Paralympics swimmers

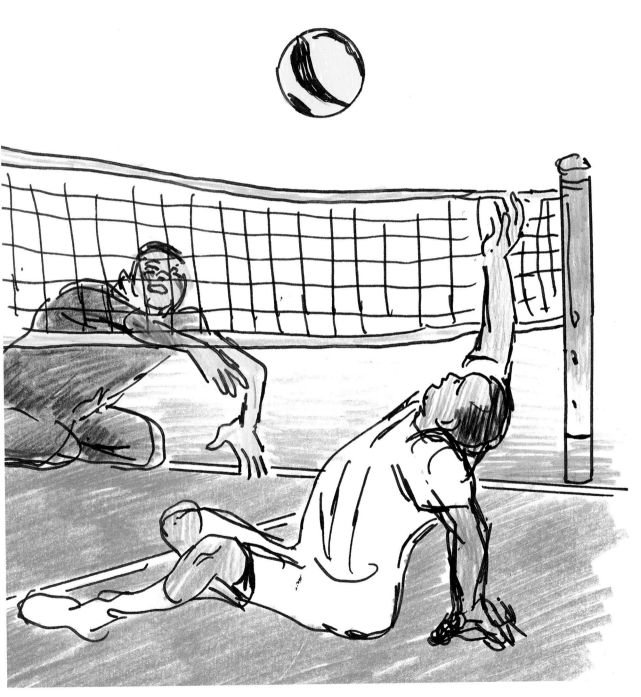

'All of the Paralympians had trained as hard and competed as fiercely as any of the athletes in the Games.'

Men's sitting volleyball at the ExCel Arena

Goalball at the Copper Box in the Olympic Park

Blind 5-a-side football at the Riverbank Arena in the Olympic Park

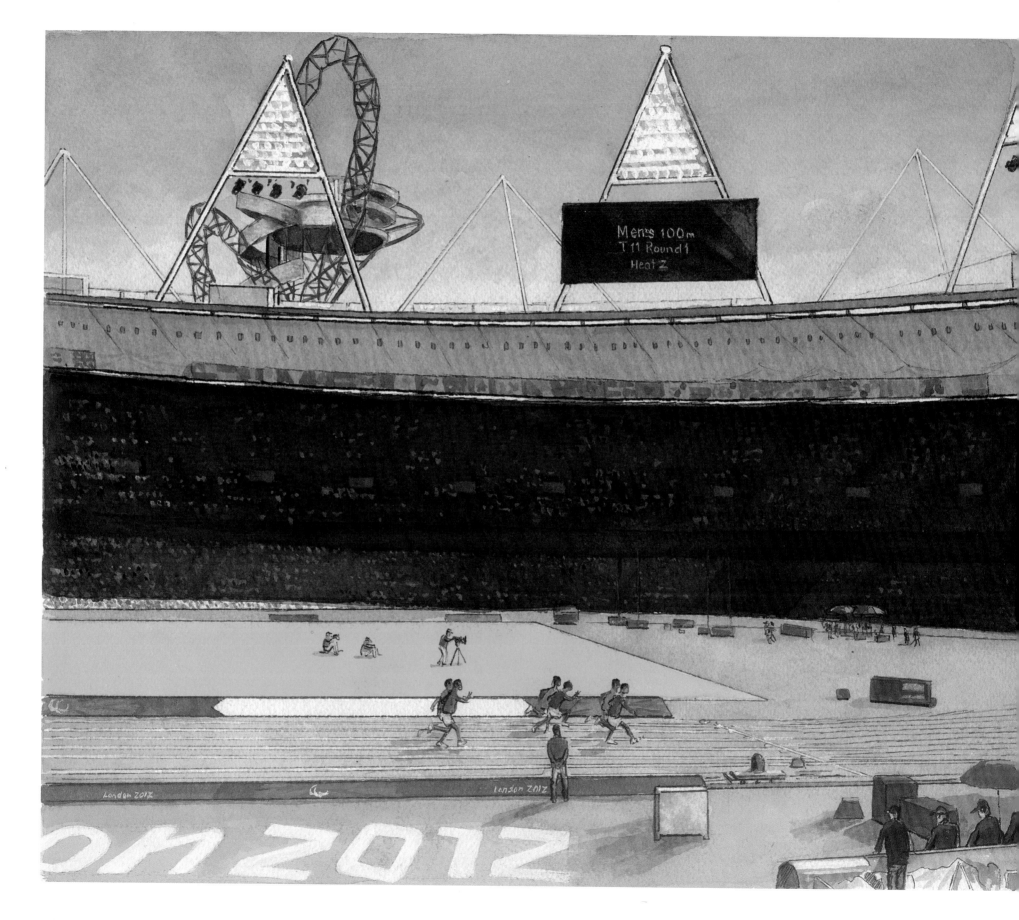

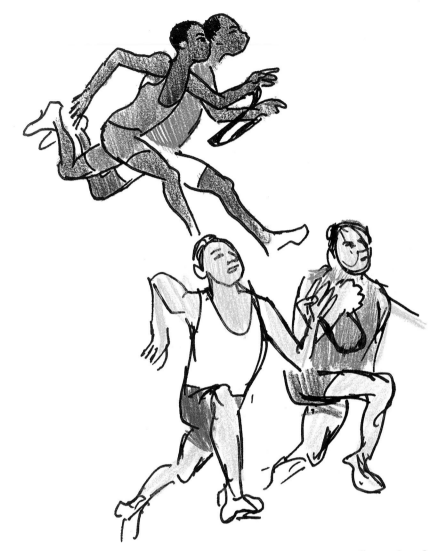

'Now and again the achievements
of the Paralympians were brought
home. For example, watching the
blind sprinters racing alongside
their guides made me realise how
long and hard they must have trained
together to build up such total trust.'

83

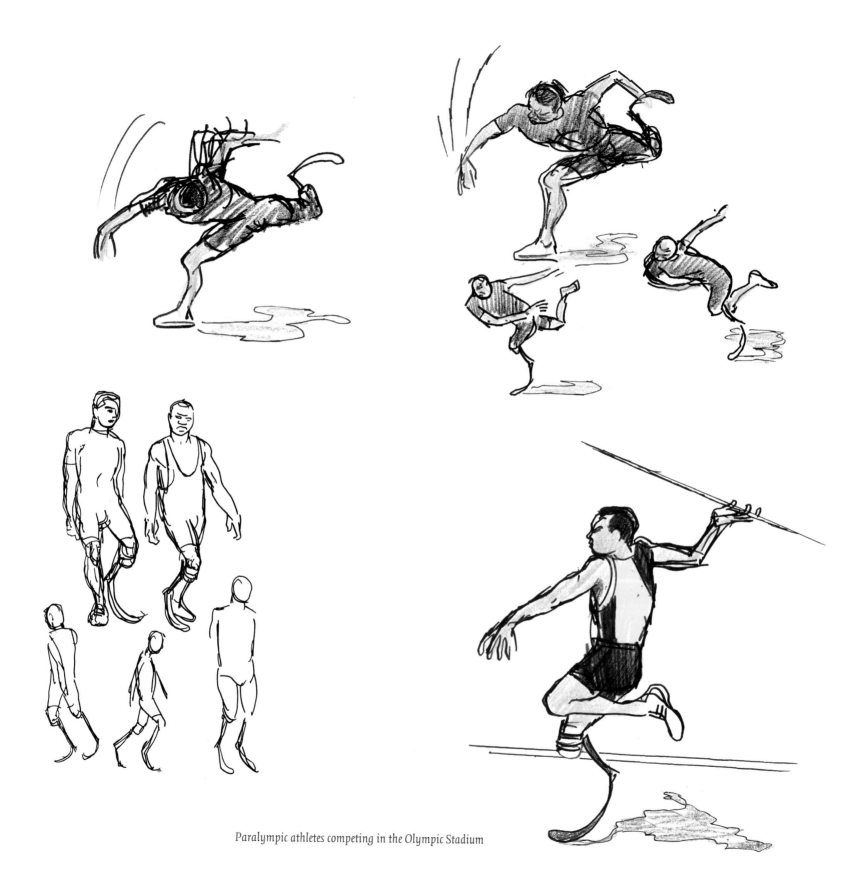

Paralympic athletes competing in the Olympic Stadium

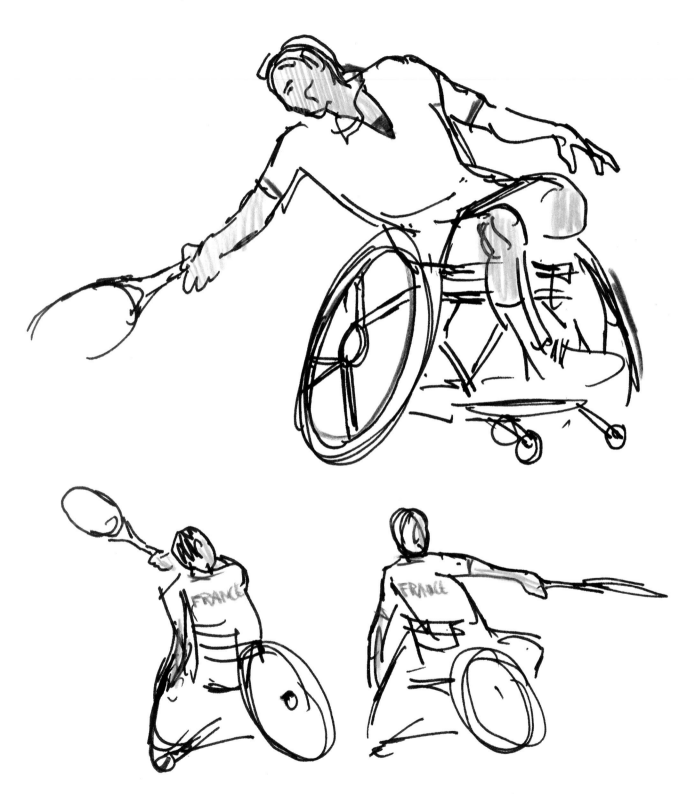

Men's wheelchair tennis at Eton Manor in the Olympic Park

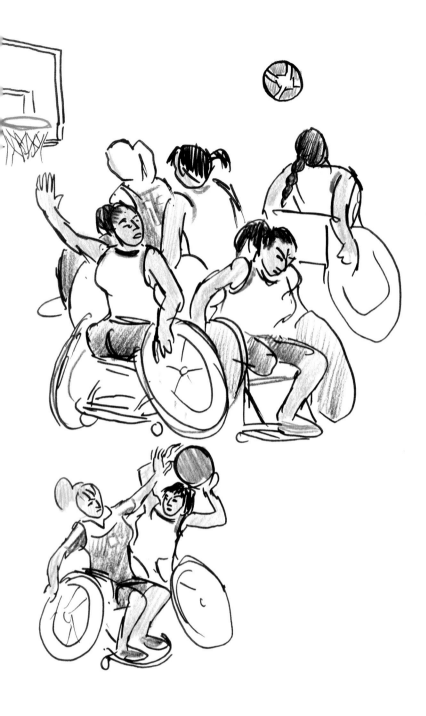

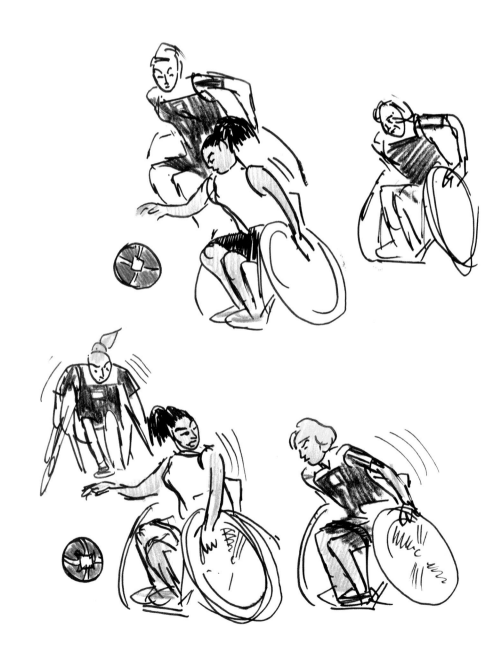

Women's wheelchair basketball in the Basketball Arena of the Olympic Park

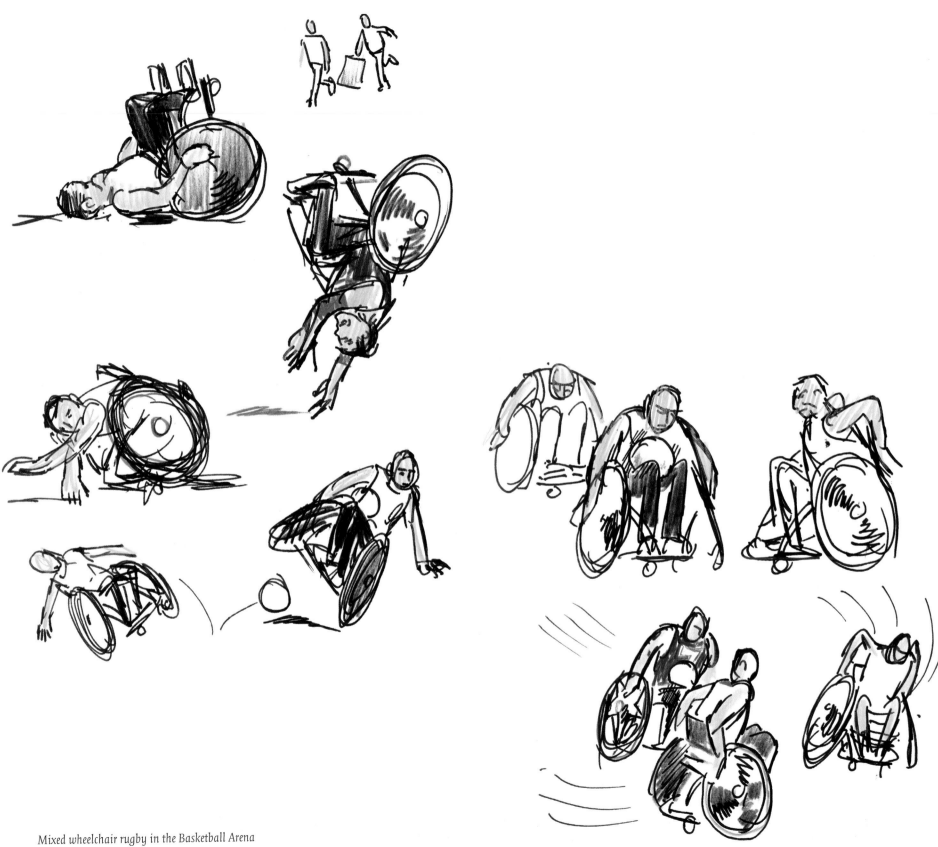

Mixed wheelchair rugby in the Basketball Arena

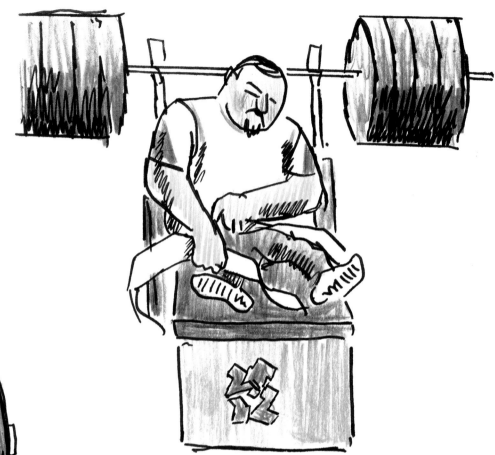

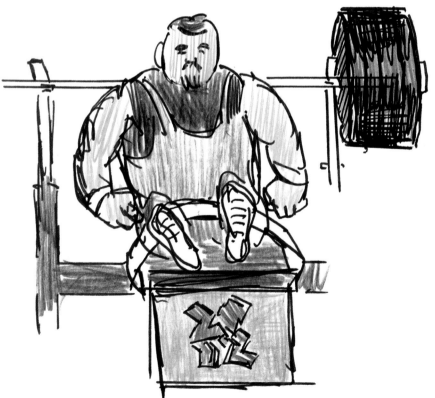

'Each time I watched a new competitor approach the weights, I thought "You can't possibly lift that much" – and then was astounded when they did. All the Paralympians had trained to push themselves beyond ordinary limits because they wanted to win. Like all athletes, they were after gold and that was all that mattered – to them competing and to us watching.'

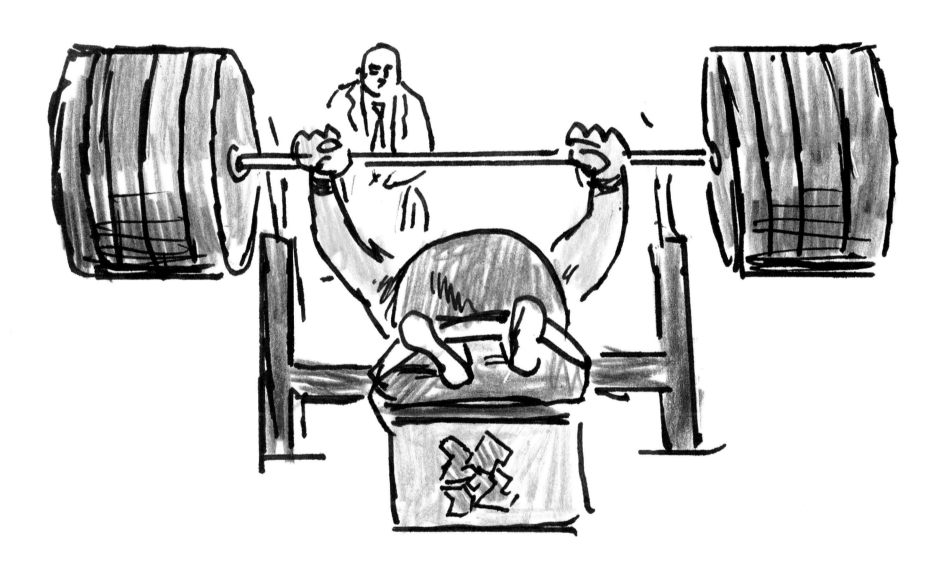

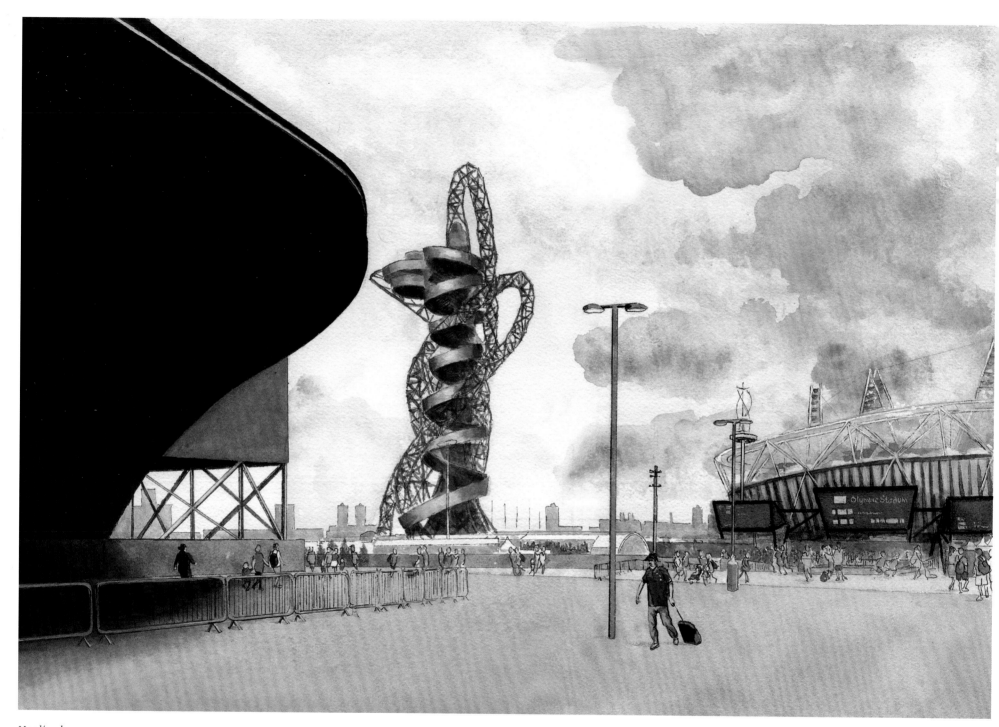

Heading home

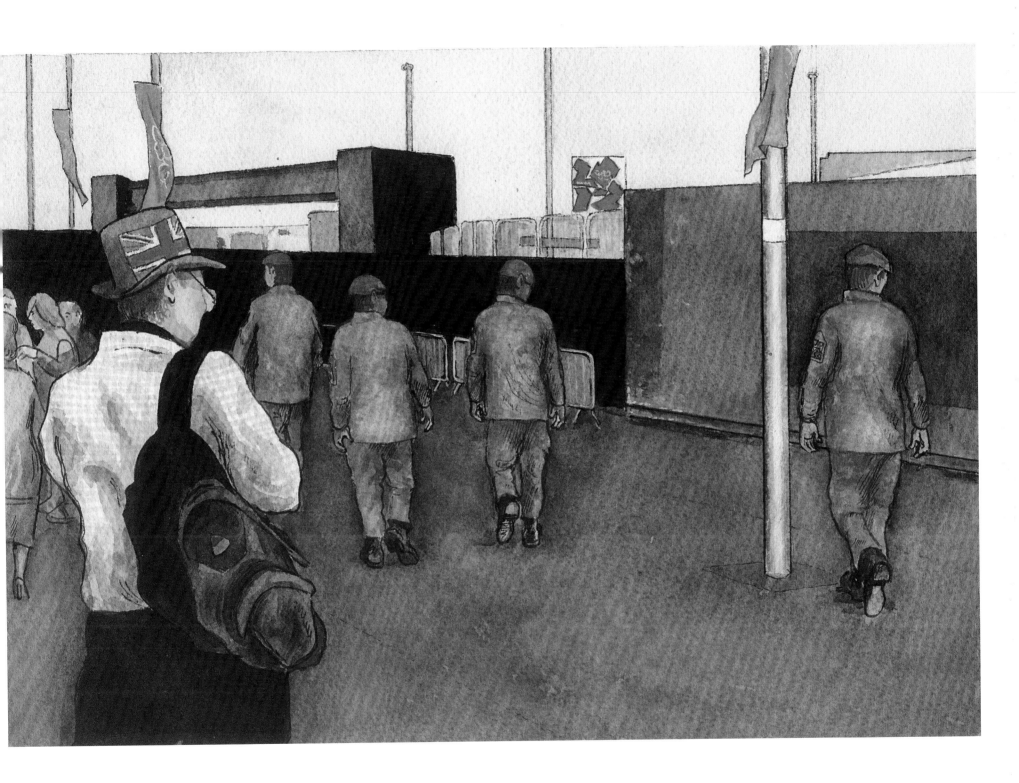

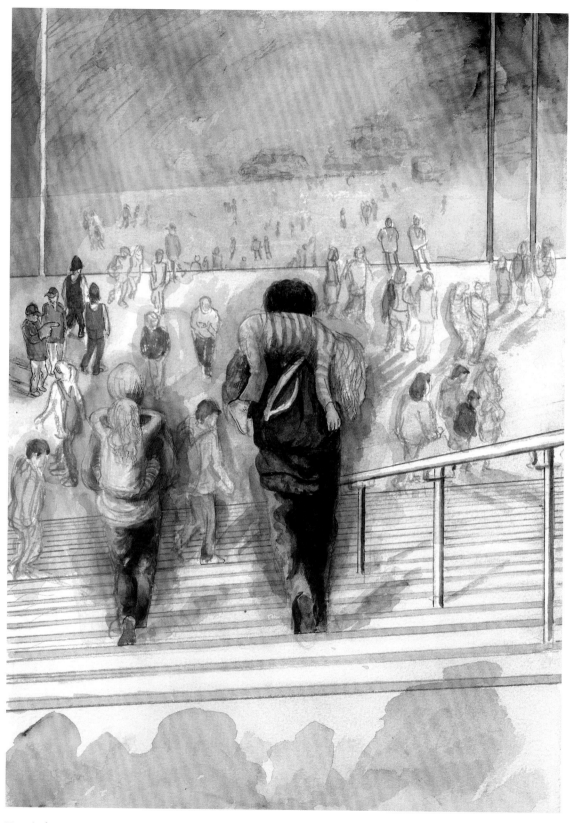

Two tired spectators get a lift home (above), while a policeman high fives the crowds as it heads towards the Tube (opposite)

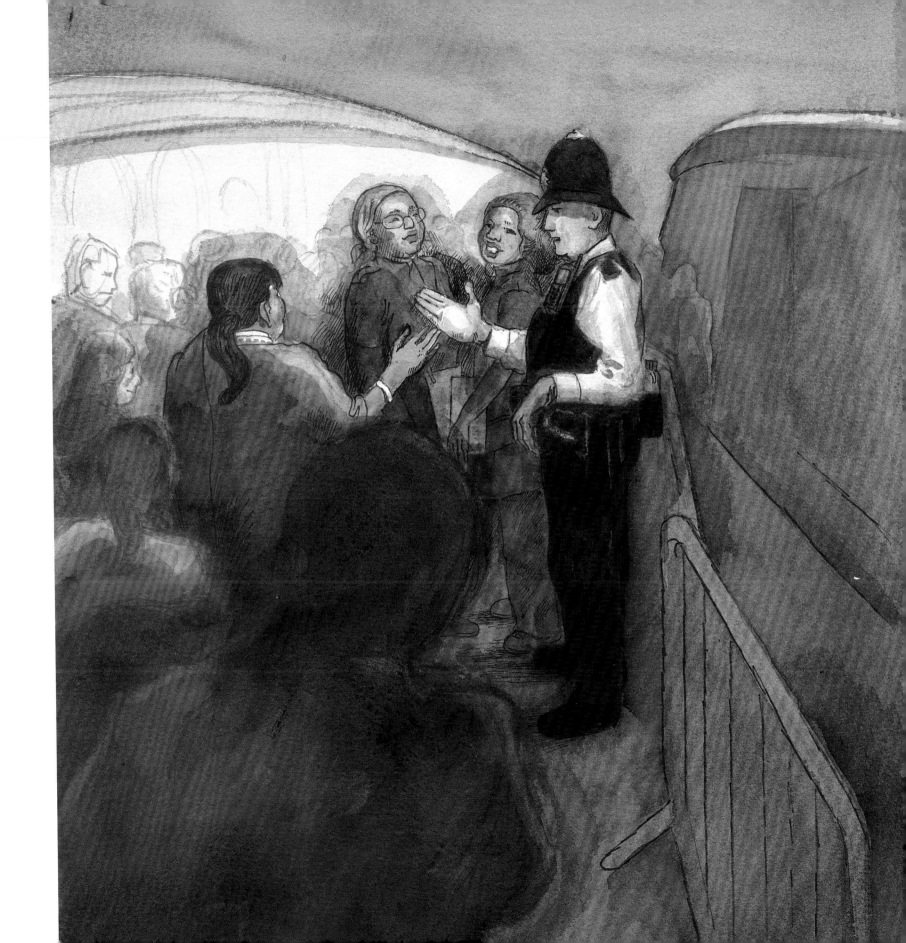

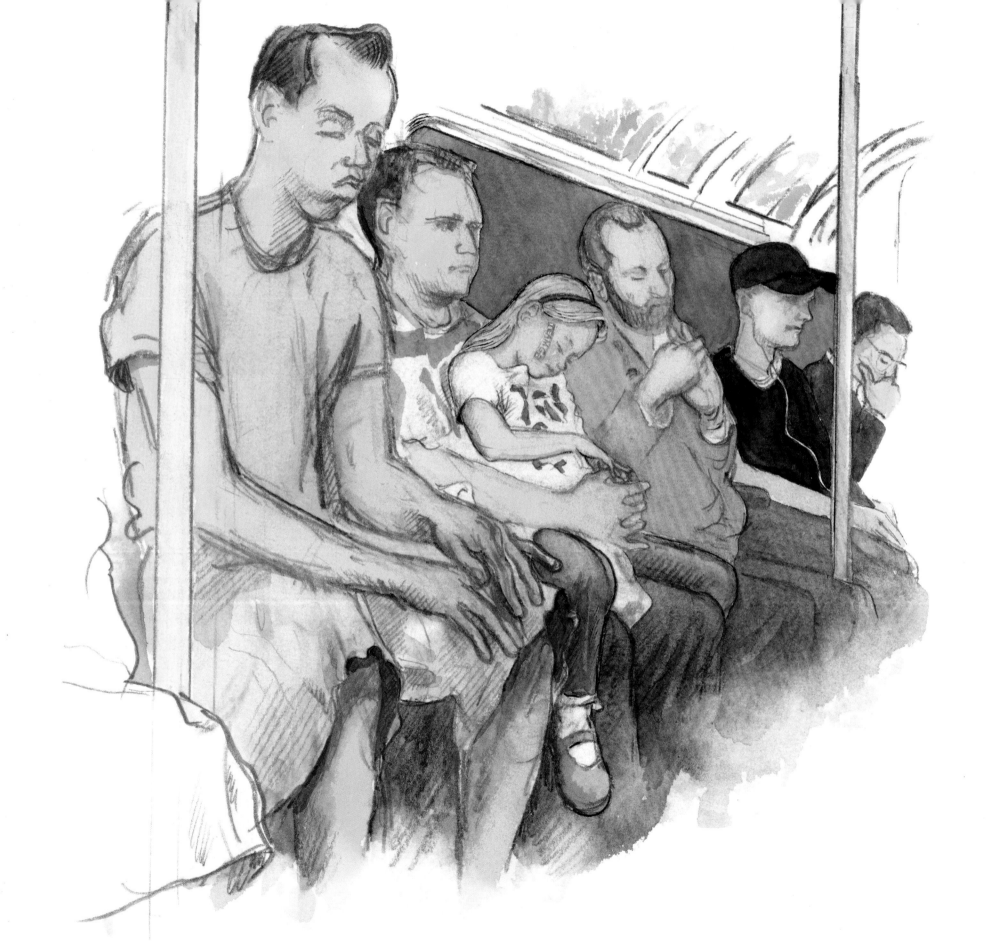

'The tattoo on the face of the little girl on the Tube home read "Team GB". While for her and her fellow travellers, the day's excitement was over, some patriotic fans didn't want it to end.'

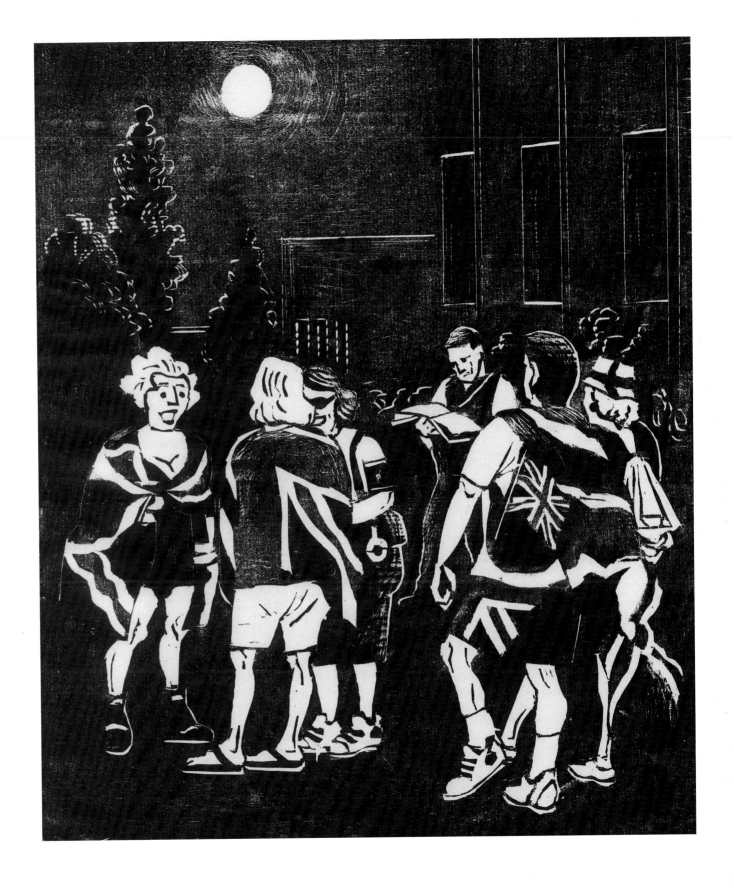